WORN IN NEW YORK

WORN IN NEW YORK

68 Sartorial Memoirs of the City

EMILY SPIVACK

ABRAMS IMAGE, NEW YORK

"It carries on its lapel the unexpungeable odor of the long past, so that no matter where you sit in New York you feel the vibrations of great times and tall deeds, of queer people and events and undertakings."
—E. B. WHITE, *Here is New York*, 1949

INTRODUCTION

In New York City, we wear our clothes hard. We grind the soles of Converse and Manolo Blahniks into the pavement. Over the course of a hot summer, we sweat through crisp white T-shirts until they're a dingy gray. We hire cobblers and tailors to keep things from falling apart, and we schlep our laundry by hand and cart to laundromats and drycleaners. Our clothes are worn, and they get worn out. Our bodies help them disintegrate into the landscape of the city. The wear-and-tear is proof that we are active participants in city life.

And New York touches our clothes and leaves its own traces, too. The moment we walk out the door our experiences get mapped onto or absorbed into what we're wearing. Our jeans get splashed with muck from a passing bus. Fellow passengers trample our shoes in an overcrowded subway car. An air conditioner in a window overhead drips onto our shirts. And, until recently, a night in a smoky bar would live on our clothes for days. Whatever choices we've made about why we put on the clothes we wear—fashion, comfort, creative expression, protection—the city will have its say.

The only thing between our skin and the city is our clothing, simultaneously shielding and exposing us. Our bodies press against our clothes just as the city presses back. As the British cultural theorist Elizabeth Wilson described in her book, *Adorned in Dreams*, "A part of this strangeness of dress is that it links the biological body to the social being, and public to private...[The body] is an organism in culture, a cultural artifact even, and its own boundaries are unclear."

Those public-private boundaries blur in New York, a place where you are rarely in isolation, and where you are often seen and watched. The sidewalk is a runway—even more so than the runways at fashion week—as is the bus stop, the line at the bodega, and Central Park. Unlike in cities that depend on cars, we put ourselves on display in New York. The construction worker in steel toe boots, the tourist in trekking gear, the woman

in her suit, the high school kids with backpacks and skinny jeans are all juxtaposed: We absorb the looks of everyone around us, all of us on the D train together. A few flaunt. Some observe. Many disappear in the sheer volume of people.

The flaunters, the observers, the invisible—I watch all of them. I take in and catalog their sartorial cues. I learn a lot from what people wear (and also from what they read, eat, how they look at their phones, how they look at each other). That's one of the reasons I chose to live in New York. When I'm away from the city for long periods of time, I feel depleted. I miss the looking. And the speculating—I always find myself imagining what the people of New York are doing when they are not sitting across from me on the train. What are their stories?

It is that curiosity which drove me to make *Worn in New York*. I didn't want to merely imagine the lives of strangers, so I asked sixty-eight real people for real New York stories centered on an item of clothing that had meaning for them. I interviewed artists, writers, doctors, musicians, athletes, astronauts, fashion designers, performers, architects, squatters, firefighters, business people, and bodega owners. I began each interview by asking the same question: "What piece of clothing reminds you of a significant moment or experience in New York City?"

That question had been refined from an early incarnation of this project in 2010. Back then I hosted a series of creative non-fiction writing workshops at places such as Philadelphia's Institute of Contemporary Art. I had a suspicion that clothing might be a catalyst to help people tell their stories, so I asked participants to bring something from their closet with special significance. I guided them to explore that significance, steering them through the process of divining stories from their garments.

Story, to me, is the unrealized dimension of our wardrobe. Sometimes, a glance inside

a closet is like browsing through a great essay collection. That belief led me to start the Worn Stories website in 2010, in which I curated and published contributions from friends and strangers. This eventually became the basis for my first book, *Worn Stories*, which gathered clothing-inspired narratives from across the country.

I was confident that a similar premise would flourish in New York City, a densely populated place with people who have come from all over the world to make their mark. For *Worn in New York*, I set out to capture the city's constantly-evolving identity, temper, and tone, and its irrepressible vitality by paying tribute to well-loved clothes and the people who wore them. Here, I've assembled a contemporary cultural history of New York City, told through clothing.

Selecting contributors for *Worn in New York* was both an intentional and organic process. I sought out notable and everyday people who were native New Yorkers, tourists, and anywhere in between, who represented diverse age groups, backgrounds, professions, and all five boroughs. But as I conducted the interviews, those stories organically shaped who I interviewed next. I cast a wide net. I reached out to friends, individuals whose work I admire, and strangers on Craigslist.

I traversed the city to interview the book's contributors. I talked to Adam Horovitz on his fire escape in Chelsea and Gay Talese over a scotch on the rocks at his townhouse on the Upper East Side. Michaela Angela Davis showed up at a Clinton Hill café wearing the piece from her story, and Ariel Churnin slid her stolen garment to me across a café table in Bushwick. I met Billy Gonzalez at his namesake bodega in the Bronx and Betty Halbreich over tea sandwiches at her office at Bergdorf's. I spoke to contributors over the phone who now live in California, Pennsylvania, Maine, North Carolina, and Texas.

As I heard more and more stories, I watched a multilayered map of New York emerge, linking contributors who likely had never crossed paths. Mirah Zeitlyn told me of her underwear that got ripped while training for the 2015 New York City Marathon, the event that George Hirsch founded nearly forty years before. Both Jenna Lyons and Lisa Bonnani had firsts at The Met—Jenna described her first time at the Met Gala, and Lisa described her tradition of wearing the same shirt on every first date, including

one to The Met. The many unexpected intersections, like these, made the city feel both smaller and less daunting.

The stories within *Worn in New York* span seven decades, and its contributors range in age from their mid-twenties to mid-nineties. But there are innumerable people I wish I could have spoken to who are no longer alive. I would have loved to ask photographer Bill Cunningham about the blue jacket he wore everyday to photograph New Yorkers or hear James Jarrett Jr., a.k.a. "Buster," talk about the uniform he wore for seventy years as Henri Bendel's only doorman. Socialite and philanthropist Brooke Astor might have talked about the white gloves she wore to present charitable donations at a public school or gala, and Jack Kreindler, co-owner of the 21 Club, could have told me about the cowboy attire he wore around New York City when he wasn't at his restaurant. And that's just to name a few.

Knowing I couldn't speak to these iconic figures motivated me even more to make this archive of sartorial memoirs of the city before the storytellers and their clothes— which will inevitably be thrown out, given away, or fall apart—are gone. But this book isn't about wistfulness for times past; rather, it's about documenting stories that emerge between the quotidian and extraordinary moments that only New York can offer, creating a living history of the city.

Clothes are the tangible material of memories. They reveal the historical, the cultural, and the personal. That's especially true in New York where they accompany us as we live our lives in public. No matter if you were born in New York or visited for a single day, every one of us who has moved through the world's ninth largest city has experienced it clothed. And each of us has a story to tell. Here are some of those stories.

—EMILY SPIVACK

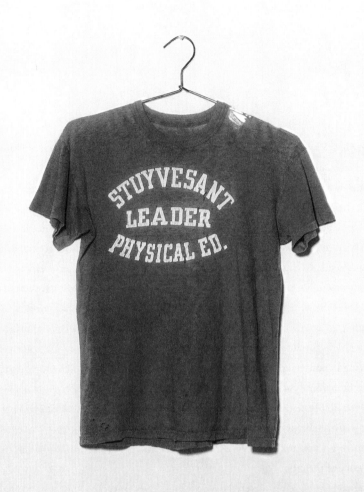

ADAM
HOROVITZ

I don't exactly know how I ended up with this T-shirt. It had been Kate Schellenbach's and we used to be in Beastie Boys together. I must have borrowed it from her when I was fifteen. I liked it because it was comfortable. And because it was Kate's, who I thought was so cool, especially because she was a year older than me, which was a big deal then. I liked it more because while I hadn't gotten into Stuyvesant for high school, she had. That was the smarter kids' high school. I got into Brooklyn Tech, barely. Before I dropped out, I used to cut school and hang out at Stuyvesant.

We all used to hang out at places where our parents weren't. We'd go to a record store called the Rat Cage. We'd go to punk shows, like Black Flag at the Peppermint Lounge, because kids could go to clubs back then. If a band was playing, you were guaranteed to see your friends at the show. You couldn't text and say, "I'll be on this corner," but if you wandered around the East Village, around St. Marks, you'd run into one another.

This was an era of having to figure things out for yourself. You couldn't ask older kids, because it was uncool. You certainly wouldn't ask your parents or go to the library. You see movies about these small towns where kids just wander around, and that's what it felt like in New York, sitting on stoops, waiting for things to happen. Kate and I were lucky to grow up downtown. We'd walk down Eighth Street to the ice cream place that also had video games, and we'd hear music coming from stores. We'd see places selling T-shirts and posters of the Clash, and we'd read about shows in the back of the *Village Voice*. That's how we found out about stuff.

I wore this shirt during my transition from a kid to a little grown-up, when my friends and I began going to clubs to mingle. You were so awkward and your whole thing was to not be awkward. You'd have so many conversations in your head about not being awkward. As a kid, it was a huge deal to leave the club with somebody, go around the corner, and make out with them. Those experiences were little glimpses into grown-up-ness, like the

first time someone in your group of friends has sex and you realize that you could, too. It's interesting for any group of friends to go through this, but it's especially weird to go through it in New York, and for the clubs to be Max's Kansas City or Mudd Club.

When our first record was about to come out, we had a photo shoot with Lynn Goldsmith, a big rock photographer. I was wearing this Stuyvesant T-shirt and Adam Yauch was drinking a carton of milk—I have no idea why. The record blew up, so the photos were everywhere. I wore it in the "Fight for Your Right" music video, too. And I brought it when we went on tour and opened for Madonna in 1985. All I brought was a messenger bag with two pairs of pants and two shirts. I'd never been on tour, so I didn't know what you were supposed to do and I didn't have very many clothes. I didn't know I was supposed to care about what I wore. I'd just wear a shitty shirt and shitty pants— I had no style. My best friend was always calling me a "walking pile of dirty laundry." Different bands like the Clash, the Sex Pistols, X-Ray Spex—what they looked like was so important. I don't know why people liked our band, because if you look at the pictures Lynn took, those guys look like slobs, and not cool slobs.

It was a really good time in New York. Rap music was taking off, break-dancing was becoming a big thing, and right around that time I was in this limbo between styles. I was a punk rocker and then when we started playing shows and I was making more money, I could afford fresh kicks. I got a pair of Playboys. I got new jeans that I could taper with laces like the break-dancers would do. I got a Puma suit.

My style evolved since the days of that T-shirt. Not drastically, but I embraced that I was going to *have* a style. I'd see Jam Master Jay and want what he was wearing. Lee Jeans because Jordaches were dead. No more British Walkers. I had to get Adidas. It was all in the details.

—*AS TOLD TO EMILY SPIVACK*

Adam Horovitz (Ad-Rock) is a musician best known as a member of Beastie Boys. He is a native New Yorker.

ALICIA
VAN COUVERING

My first shoplifting memory is from when I was twelve years old with my friend David. He went to an all-boy prep school, Collegiate, and I went to its all-girl "sister" school, Brearley. We lived across from each other on Seventy-Ninth Street and West End Avenue. We became friends because we were both nerds. We would go to FAO Schwarz, ask for empty shopping bags, fill our bags with stuffed animals and Pikachu stuff, and walk out. Or we'd go to Tower Records. I would be holding an Ace of Base CD and be like, "David, I need to put something in your bag." I'd drop the CD into his bag while pretending to root around for my wallet. That was our master plan. Two twelve-year-old nerdy kids stealing stuff. We were so brazen, and that was the fun of it. David got caught at HMV or Tower Records, so he stopped, but I kept going.

In high school, I spent a lot of time by myself. I'd go from Stuyvesant, in Battery Park, to Yonah Schimmel's on the Lower East Side to get knishes, and leave with a stolen bottle of water in my hand. I'd go to an acting audition or internship in Midtown, and hit a few sample sales on my way home. Sample sales were an amazing place to steal from. They'd be in some weird walk-up in Bryant Park with a bunch of twenty-two-year-old girls sitting behind a table not paying attention.

I had a specific method for shoplifting clothes and I used that method to shoplift this sweater from Century 21, which was right near my school. I would embody the character of a "very distracted high schooler." I would put my winter coat over my arm. Then I would put a sweater over the coat, completely visible, as if it was something I planned to buy. I'd channel this really tired, dehydrated, stressed-out girl persona with all these heavy school bags and a big coat, then wander out of the store with a dazed look on my face. If someone stopped me at the door with a sweater like this one hanging over my coat, I would act shocked, like, "Oh my God, of course! I totally forgot . . . ," as if that routine would fool anyone. If I did get stopped, I just acted embarrassed and gave it back.

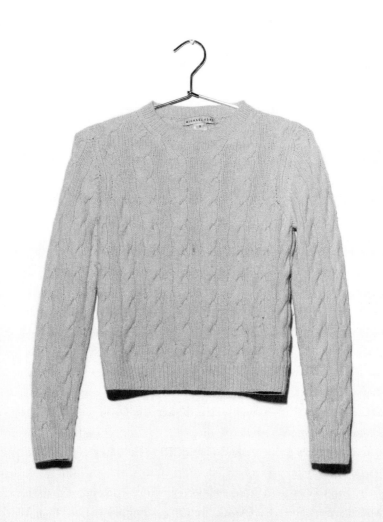

This went on until I was sixteen. Once, again at Century 21, I was doing my usual routine and tried to walk out with, like, four sweaters over my arm. The alarm went off and the security guard said, "Excuse me, ma'am, are you going to pay for that?" I acted all surprised: "Oh gosh, I'm so sorry. How stupid of me." And then I tried to walk out another door and was stopped again. That security guard was like, "Could you hang on one moment?" I had bought a pair of socks before trying to leave, which I thought made it a very convincing performance piece. Like, I am the kind of person who buys things; all of this stuff is on my arm by accident.

A different Century 21 employee met me at the exit and asked me to follow her. She took me downstairs to a windowless room and asked me to wait on a bench. Next to me, there was an African American woman handcuffed to the same bench, looking extremely tired, like she had been there for a long time. I guess we'd both been caught shoplifting, but I was certainly not handcuffed. They asked if I wanted a glass of water. Everyone was very nice to me. They took me into another room and asked for my address and photocopied my ID. They didn't even say, "You're here because you were shoplifting." It was more like, "If you don't mind . . ." A few weeks later I got a letter at home saying that I was banned from Century 21 forever.

That was the end of my shoplifting career, because the arrogance of what I was doing suddenly dawned on me. The woman handcuffed to the bench was criminalized for the thing that I had been given a pass for a million times. I don't think I entirely made the connection at that moment, but I recall feeling a lot of shame, which I had not felt before. It had been a fun game—like, who was I hurting taking expensive shit that no one cared about anyway?

I wasn't a bad kid, but I was pleased with myself for being a brilliant criminal. I'd been raised with a healthy skepticism toward authority. I thought that I was right unless proven wrong, that rules were mostly arbitrary. Really, it's that I knew I would never actually get in trouble. What a little jerk. It didn't even occur to me that something like this sweater couldn't just be mine.

—AS TOLD TO EMILY SPIVACK

Alicia Van Couvering is a film producer whose work includes *Tiny Furniture*, *Drinking Buddies*, and *Cop Car*. She grew up in New York and currently lives in Los Angeles.

AMY HECKERLING

I grew up between the Bronx and Brooklyn without a lot of money. Most of my clothes were hand-me-downs from my mother's cousins or kids at school. I learned to be OK with that. But you never feel OK when someone says, "I remember when I used to wear that."

In September 2001, my agent invited me to the MTV Video Music Awards at Lincoln Center. I didn't want to go to another event only to be, once again, the worst-dressed person. I thought perhaps if I wore expensive-ish shoes, I could make up for it. I got a pair of Manolo Blahniks. Everybody was making such a big stink about them at the time. I figured, if they're that expensive, they must be comfortable.

That day, I couldn't get a cab because the streets were blocked off. I started running because I didn't want to be late. And then the heel of these expensive shoes broke. I limped the mile and a half to the awards.

I had an ex-boyfriend who had a film coming out. As I approached the VMAs, I saw that they were giving out masks of his face making a stupid expression as a promotional thing. All I could see were these faces of him. If it were a movie, you wouldn't believe it.

I was wandering around, one heel up, one heel down, with all these faces of my ex-boyfriend around me, pissed. I was getting told by various guards and velvet-rope people to move out of here, get out of there. I had this feeling like, "You're a loser. You can't get in. You can't even wear a nice pair of shoes without breaking them." I couldn't reach my agent, so I went home.

A few days later was 9/11. And those shoes, which I've held on to since, became symbolic of what not to give a fuck about. When shit hits the fan, you should be wearing shoes you can run in, shoes to get you out of trouble, shoes that are comfortable. Who cares what label you are wearing? I had always known that, but I still tried to make a concession to what everybody else was doing, which in hindsight, I realized was idiotic.

—AS TOLD TO EMILY SPIVACK

Amy Heckerling is a director, writer, and producer whose work includes the films *Clueless* and *Fast Times at Ridgemont High*. She was born in the Bronx and currently lives between New York and Los Angeles.

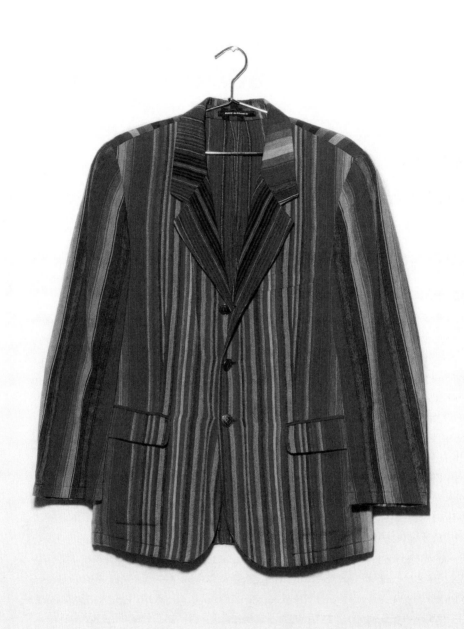

ANDRE
ROYO

We were waiting for a buddy of mine to play basketball with. When he showed up, we were like, "Yo, where were you, man?" and he was like, "I just came from downtown." I didn't know what he meant. Because at that point, until I was about eighteen, I never went downtown. I grew up in the Bronx. My friends were in the Bronx. The girls were in the Bronx. To me, "downtown" just sounded weird.

In the late 1980s, I went away to a small automotive business college in Florida. When I came back in the early 1990s, that same friend had a hi-top fade. He was wearing these weird Doc Marten boots that I'd never heard of and baggy, colorful, collage-y-type pants—he looked ridiculous.

I was like, "What are you doing?" He said, "You gotta come downtown." My other buddy came with us. He had rings in his ears and nose. I was like, "What the fuck is happening to my people?" After being in Florida for four years, I was wearing Top-Siders, acid-washed Pepe jeans, and a Polo V-neck sweater. I looked like Carlton. They took me to this club called The World with club music, house music. I was like, "Where are the words? Where is hip-hop?"

That was the first time I saw something multiracial, everybody hanging out, real sexy, and I was like, "Wow!" Downtown, there wasn't race. It was a class system. Everybody was cool, dressed in unique shit I hadn't seen before. In Florida, and even back in the day in the Bronx, I always looked pretty good. My mom and dad had some money and I looked put together. This chick asked me if I was having a good time, if I thought The World was dope. I was like, "Yo, it's all right. But I don't know if I'll go back." She looked me up and down and said, "No wonder you're not having a good time. Look at what you're wearing." I had never heard that before. I was devastated. What the fuck?

I started hanging out downtown. Not even downtown; I couldn't venture past Fourteenth Street because it was so weird. Sometimes I would go to Harlem to hang out

because it was kinda cool. I had crazy hair, and this French lady, the photographer Martine Barrat, came over to me one day in Harlem. She was like, "What do you do?" I said, "I'm trying to be an actor." She got me a job that forever changed my life at a store on Prince Street called agnès b.

The first time I walked into agnès b., I had on a bubble goose vest and some Lees. One of the employees said, "Are you here for deliveries? Go around the back," and I said, "No, Martine sent me. I'm getting a job here." They gave me the side-eye like, "They don't hire guys like you."

I got the job. While I was getting a little tour around the shop, they showed me fucking dress shirts with price tags that were $400. I was like, "What are you talking about?" I would go to Syms in Yonkers with my dad and buy three suits for less than that. I was like, "Who shops like this?" My mind was blown when I started working there.

There was one black chick I worked with who was from the Bronx, too, but she had been downtown for a while. We kind of clicked. I was like, "This is crazy. People shop here?" And she was like, "Yeah, it's beautiful." And then my now wife walked into the store. She worked there. This short little Asian girl with a crop-top sweater, these tights with dots, Doc Martens, a little skullcap, and freckles. I felt like Captain Kirk. I went, "What the hell is that? That's the one I want right there," and the girl said, "Oh no, you can't mess with Jane. She's too worldly for you and she's got this Jamaican dude." After that, I went on probably my best acting job ever. I made myself a different character to win her over. Just swooned her the best I could, and we've been together for twenty-five years.

There was a jacket at agnès b. made from this Guatemalan-type material but in the cut of a blazer. It looked crazy. I thought, "This jacket is cool, but I can't pull this off." I felt like I'd be perpetrating. I couldn't walk with confidence. So I walked away from it.

My mom and dad used to tell me, "Don't splurge-shop. If you like something, look at it. And if you go back and it's still there, it's meant to be. But you gotta commit." I thought about it the next day. Came back. Put it on. And when I was looking at myself in the mirror, somebody was like, "Yo, that looks like you. You can pull that off," and I was like, "Nah, you buggin'," so I walked away again.

The third day I walked into the store and saw the jacket again. I started thinking about how people encouraged me to be an actor. How they meant it with love. How I had support from my mom and dad, from my boys. How they believed in me more than I believed in myself. I thought, too, about my friend who had been downtown, how we were like, "Wow, it's time we live outside of this small box. It's time to explore. We want more." I saw all of that in this jacket.

I bought it and put it on. I walked outside on Prince Street to head back to the Lower East Side, which is where I lived by 1993. My walk was kind of confident and kind of like, "I like the way this feels so fuck it, whatever." I was walking slow and a couple of people were like, "Awesome jacket, man!" You hear that and your back straightens up a little more. You walk that *Saturday Night Fever* walk where you start bopping a little bit. And people started saying, "Yo, that's a dope jacket, man! Where did you get that jacket?" and I was like, "I know! I know it's a dope jacket, motherfucker!"

My crew in the Bronx would say, "Only you could pull off that jacket." I loved hearing that. With acting you can't make it unless you believe in you. Hearing "Only you . . ." made me feel like, "Yeah, you're right! It *is* only me. It's definitely up to me." One of Jay Z's lines that sticks with me when I've had a bad audition is, "I look in the mirror, my only opponent." If I fuck up, it's all on me. I wasn't playing in this jacket. I was being me. When I wear it now, I get the same feeling I got back then. "Only you can pull that off." And I love it.

—*AS TOLD TO EMILY SPIVACK*

Andre Royo is an actor known for his roles in *The Wire* and *Empire*. He grew up in the Bronx and currently lives in Los Angeles.

ANDREW
LAMPERT

I first met Tony Conrad in 1998, but I'd been aware of him for years as an avant-garde musician and clandestine figure. I knew about his history of performance and that he was indirectly responsible for naming the Velvet Underground. He was this safety pin in the twentieth-century New York art world who held so many different movements and groups and individuals and aesthetics together.

I got a chance to work with Tony, and we developed a friendship and professional relationship. When I'd go over to his house, he'd hand me a dress, smock, kimono, or big blouse, and say, "Here, Andrew, get comfortable." We would put on wild clothes and hang out. Tony had clothes for all sizes and genders. He didn't seem to hold any normal notion of matching, and he wore the flashiest, ugliest clothing you could ever imagine.

One time, in 2007, we went to a thrift store together. I wish I had filmed it. It was like a nature documentary, like looking at the hunting techniques of a wild lemur. Tony looked at clothing in this rigorous, structurally minded way. What are clothes? What is their function? How do people wear them? Where do people acquire them? How do people clean them? His intellectual curiosity and the ways he engaged with the world extended to his fashion sense. He would buy clothes he didn't understand but whose function he wanted to come to grips with.

Tony had a lack of self-consciousness in his daily life. He didn't care about the decorum for an occasion. He would show up wearing a too-big suit the color of mint chocolate chip ice cream. You'd see that and think, "Only Tony Conrad could pull that off." His fascination with even-Goodwill-doesn't-want-this fashion was rooted in a time of being poor in New York, of scavenging off the street, before he was a professor with a comfortable salary and a primo gallery. The man stayed true to his tenement apartment Lower East Side origins, from when he lived in a land of make-believe with filmmaker Jack Smith in the 1960s; they existed out of time and out of fashion.

Among the different things you could call Tony—filmmaker, musician, artist, teacher—I think *fashion icon* nails it. I don't know anyone else who dressed like him in New York, where people are decked out in the most diverse ways possible. I liked running into him at events in the city. You'd see this tall guy from afar, standing in the corner wearing a bright orange jacket or horrific egg-carton-yellow pants, and it would be like, "Oh, Tony's here." I liked that his clothes were his calling card. He achieved it without trying, without thinking. It was natural and naturally tasteless.

While Tony wasn't my mentor, and I wasn't a devotee or student of his, I still feel like I got so much from his fashion, the ugliness of the clothes he wore, and the way he could rock pink pants. Tony's oddball sense of style unleashed in me this desire to have clothing that would allow me to let loose. I decided to diversify from the neutral tones I usually wore and got my first pair of salmon-colored pants. Once, he and I were at a dinner party and we realized we were wearing almost the same pants. We were so happy that it had finally come to be that we were similarly pants-ed. This was just before he passed away.

After Tony died, his wife, Paige, gave me a big bag of his clothes. Inside were the salmon-colored pants that inspired mine. She said they'd wanted me to have them because only I could carry on the tradition of wearing these pants.

Recently, I wore Tony's pants to the Saint Thomas Church on Fifth Avenue for a performance by Charlemagne Palestine, a significant musician, artist, and composer whom Tony discovered in the late 1960s. Charlemagne played a memorial tribute to Tony at the church and people listened outside on the street. When I get frustrated with New York and think about where else I could live, as I think everyone who has lived here for a while does, that performance is a perfect example of why I'll always stay. On a Tuesday night in midtown Manhattan, I can see Charlemagne Palestine play church bells for free in a tribute to another artist I admire. I can stand on a street corner in New York with my wife and daughter and experience this. And if I want, I can do ten other things on the same night that I can't do anywhere else in the world. It's an embarrassment of riches. Tony is New York to me. Wearing his pants reminds me of why I want to be here.

—AS TOLD TO EMILY SPIVACK

Andrew Lampert is an artist and film archivist whose work has been exhibited at the Whitney Museum of American Art, the J. Paul Getty Museum, and the Solomon R. Guggenheim Museum. Currently living in Brooklyn, he has been in New York since 1995.

ANNA
SUI

Little by little, because of outsourcing and economics, the Garment Center is disappearing, turning into condos, hotels, and restaurants. There's less available space for this little pocket of New York that really housed the whole garment industry and employed many people—especially immigrants who made a career of making clothing. I'm not very political, but as I saw it changing, I had to do something.

Nanette Lepore and I, along with designer Yeohlee, who was the strongest advocate and most political one of all of us, established the "Save the Garment Center" campaign in 2008. We held rallies and called representatives to bring greater visibility to the area.

Without the Garment Center, I couldn't have built my business the way I did. When I first started, everything was at my fingertips within a few blocks. A little old guy used to cut zippers to the length I needed. Another guy would make buttonholes with a buttonhole machine. Nancy was the go-to person for snaps and grommets—I'd go to see her at Sure Snaps, which closed, but luckily now she's at Steinlauf & Stoller. I used to say hello to twenty people walking down the block, because they were my fabric salesperson, my button guy, my trim guy.

Once, I walked into this fabric store, Plitt Segal, which had been around since the 1940s, and I saw all these beautiful velvets. I asked the owner, Julie Segal, "Why is all the velvet so stiff? Why don't you wash it so it's more like vintage clothes?" He said, "You know, that's a good idea," and he tried it for me. They're still running that washed velvet—it became a staple of their repertoire. Julie was also one of the first people to offer me credit—I could order fabric from him and I'd have thirty days to pay. That was how I built my business. I would get to know business owners, they would see I was earnest about what I was doing, and as my business got bigger, they were the ones who really supported me.

One of my favorite things was wandering into old fabric stores in the Garment Center and asking, "Can I go into the basement and see what you have down there?" I would find

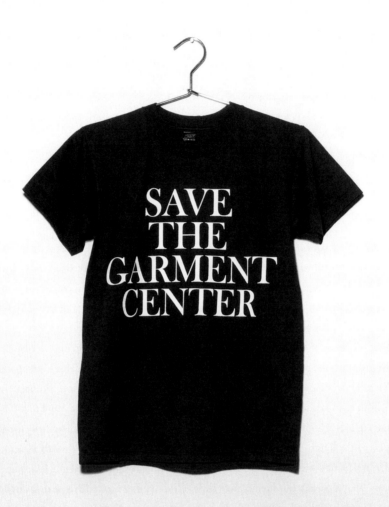

thirty- or forty-year-old stuff and it would trigger an idea. I used to do that when I was working on a new collection and I got stuck. I would walk around the block, wander into those stores, see a fabric, and my brain would start working.

As more businesses were closing, I felt I needed to make a statement about the state of the garment industry. Even though I'm not really a T-shirt person, I wore our campaign T-shirt to show my Spring 2009 collection at Lincoln Center. It's not realistic to think that the Garment Center is going to come back, but I make a concerted effort to support the businesses that remain. I always tell young designers that they have to use the resources that are available to them. You can't just wait and say, "I wish I could find this." You have to go out and find it before it disappears.

—AS TOLD TO EMILY SPIVACK

Anna Sui is a fashion designer. She was born in Detroit and founded her company in New York in 1981.

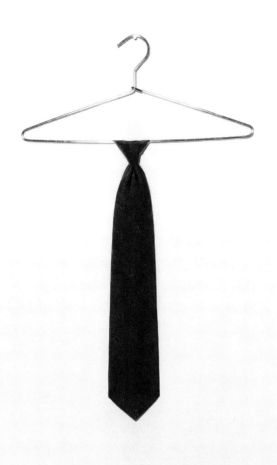

ARIEL
CHURNIN

As a female guard at The Metropolitan Museum of Art, you were given a choice between a clip-on tie like this one or a little foofy bow tie. You were given two pairs of pants, two skirts, two jackets, one tie, and five white shirts. If you wore a skirt, the stockings couldn't be exciting. No fishnets. You could dye your hair, but it had to be a natural color. Same with how you could wear makeup—natural. Whenever you finished wearing your uniform, you would put it on a rack in the locker room to get laundered and the museum would return it to you.

When you came in for your shift in the morning, you went to dispatch and they told you what section to report to. You'd go to the locker room to change and then go to your assigned section to report to your supervisor. They would observe what you were wearing and say something like, "Ms. Churnin, we don't allow knee-high socks. Please go down to the locker room and change." I think I tried to get away with those once.

You never had to stand more than two consecutive hours, and you would rotate from room to room about every half hour. You'd have a chance to spend a lot of time with the art. I really got to know the artwork in my two years as a Met guard.

But I also got to see some funny things. I first began working during the Andy Warhol retrospective, in 2012. It was horrible—very bright, hordes of people, lots of celebrities. And lots of people trying to touch the work—adults and children. You would spend most of your time telling them not to touch, not to use a flash, or not to get too close to a painting. When I was in one of the galleries standing by Hans Haacke's giant pack of cigarettes, I saw a woman walk in without a shirt. She had body paint on, the same colors as Warhol's famous Marilyn Monroe painting. She was beautiful, petite, and had yellow curly hair, almost like Monroe herself. She was flanked by these two strange-looking men wearing all black, as though they were her bodyguards. This was during my first few months as a guard, and I didn't know what to do. As she made her way past me, I just froze. I think

I mumbled, "No flash" to the two men who were following her, taking pictures. Another guard who had more experience stopped her and said, "I'm sorry. The policy is that you have to wear a shirt. I'm going to have to escort you out."

Another time I was in a gallery with this beautiful painting of Salome with curly black hair. She sits on a chest holding a saucer and a knife, alluding to the beheading of John the Baptist. A leopard skin covers the floor beneath her feet. And I saw a woman petting the painting to see if it was real fur! I knew she was going to do it. Sometimes I'd get this weird feeling that someone was going to touch something. And I'd let it rip, yelling at them not to touch. In the Persian rugs section, people would touch them as if they were checking the quality of a rug at a bazaar. That bothered me—these rugs were five hundred years old and people would be like, "It's not that great. The one in my room is better."

In one of the European galleries, I was told to look out for coins on the frame of Benjamin Franklin's portrait. Apparently, someone keeps putting quarters there, but they still haven't caught anyone.

A lot of times, people would ask me whether the paintings were real or fake.

Mostly, though, when you're wearing the Met guard uniform, people look past you. That can affect you negatively and make you feel invisible. I'd gone to museums for years and not noticed the guards—I think a lot of us don't. Since becoming a guard myself, I am far more aware. It was a humanizing experience. Now, whenever I see someone in a service or maintenance position, I acknowledge him or her as a person.

If you're ever at The Met just before 5:30 P.M., you'll see the guards begin moving visitors out of the galleries and down into the main hall. Right when the museum is about to close, you'll see hundreds of guards gathering in the main hall as all the visitors leave. Once they're gone, one of the managers will say, "You're done!" and all the guards will yell and run to the locker room underneath the Egyptian section of the museum, pulling off their clip-on ties as they go.

—*AS TOLD TO EMILY SPIVACK*

Ariel Churnin was a guard at The Metropolitan Museum of Art from 2012 to 2014 and currently works as a horticulturist in Manhattan and Brooklyn. She has lived in Brooklyn since 2007.

AUBREY
PLAZA

I stole this NBC page uniform after I was encouraged to leave the Page Program. I wasn't outright fired, but it was suggested that I leave, so I never gave it back. I wasn't used to working in a corporate environment like NBC where there are HR rules. It's fuzzy to me exactly what happened, but I think I made a joke about Jesus being crucified or I wrote it on a wall, and I got in trouble. Three or four months after I started, they were like, "Maybe this isn't right for you," and I was like, "Maybe it isn't."

There's a respect for pages because of the program's history. Everyone knows that if you get into the program, then there's something special about you. At the same time, when you're wearing the page uniform around 30 Rock, you're actually low status. You walk through the building giving tours and you stick out like a sore thumb because you're wearing this ridiculous outfit, a custom-fitted polyester uniform that makes you look like a 1950s flight attendant. And in 2006, we could only wear skirts—there were no pant options for girls. 2006! I think it had been the same uniform style since the 1950s. Now female pages have pant options, but when I was doing it, it was old school.

The main job of the page is to give studio tours: to lead a group of twenty tourists every hour and a half through 30 Rock. During the tours, I was always making up facts about the history of NBC. For example, on the soundstage where they shot *Late Night with Conan O'Brien*, you're supposed to say, "Does everyone feel how cold it is here? Can anyone guess why?" People would guess and eventually you, as the tour guide, would say, "Because there are 20,000 lightbulbs in the ceiling and in order to keep the lights cooled down, we have to keep the temperature at blah blah blah." But I would say, "Does anyone know why it's cold in here? It's because sometimes they'll bring in penguins for the late-night shows and we'll keep them in rooms that are set at a specific temperature for them." I would just make up dumb things like that to make myself feel better about life.

Another girl in the program named Meg and I made up a game when we'd give studio tours. She and I were both weird and witchy, unlike everyone else in the program who seemed to be cheerleaders or former sorority presidents. We'd say to one another, "On the next tour, you have to incorporate into your speech these three words—abortion, pineapple, and Minnesota."

Pages had to work six or seven days a week. I don't know why. I was twenty-two and I'd have to work on the weekends, which was a disaster because I was always hungover. On many, many tours, I would take a group to a soundstage, give them the spiel, and say, "OK, I'll let you guys look around for five minutes and I'll be right back." Then I'd go into the hallway, throw up in a trash can, and continue on. I got really good at giving tours wildly hungover.

After working as a page, I got a gig as a low-level intern within the casting department at NBC in the 30 Rock building. During the first season of *30 Rock*, they needed a page character in the background for one of the shots. I said, "I can do it. I'll put on my uniform and pretend to give the spiel I would actually give." I did it. My stolen uniform and I made it on to the first season of *30 Rock*.

—*AS TOLD TO EMILY SPIVACK*

Aubrey Plaza is an actress who is best known for her work in the television shows *Parks and Recreation* and *Legion*, and in the films *Mike and Dave Need Wedding Dates* and *Safety Not Guaranteed*. She lived in New York from 2002 to 2008 and currently lives in Los Angeles.

AYA
KANAI

I am a punctual person. As a lifelong New Yorker, I know how long it's going to take to get from place to place. But on February 14, 2014, there was a massive blizzard, the kind where there are no cars on the road and people are skiing in the middle of the street, where everything is white until it gets dirty and you're jumping over a puddle the size of Lake Michigan to get across the street.

I was attending New York Fashion Week as I had done every season for the past thirteen years. But I was late to the Ralph Lauren fashion show. The venue was on Washington Street, close to the West Side Highway. Because of the weather, the car-service cars were backed up in front of the venue. I was nervous about being late, so I got out of my car about two blocks away and started running. I was wearing this pair of boots that are a fashion editor's version of snow boots, which is to say they weren't a chunky Sorel boot that someone would go trekking in. As I was running down the sidewalk, I slipped about half a block from the venue and slammed my head against a building on Washington Street.

Later I learned that an editor from another magazine had found me in the snow, passed out on the sidewalk. She got security guards to drag me inside the venue. I remember opening my eyes and seeing an ambulance. They put me on one of those boards where they lock in your neck and you can't move. Thankfully a coworker joined me and called my parents.

In the hospital, I was told I had a mild concussion. I was getting asked all these medical questions, like when I'd had certain vaccinations. I had gone on a trip to Africa with my ex-boyfriend and he knew all that information, which I couldn't remember, so I texted him. He was alarmed that I'd had an accident, so he came to check on me. I imagine it was hard for someone who I was out of touch with but who I'd been in a serious relationship with for three years to see me on a gurney and in a vulnerable condition. I hadn't even realized until now that it was Valentine's Day!

The doctors told me that because I'd had a concussion, I wasn't supposed to work, check my phone, watch TV, or, if I was by myself, sleep. I was supposed to be around people in case something happened neurologically. At the time, I was living alone in Greenpoint and my parents were living in a studio apartment in Murray Hill, because their house was being renovated. I stayed on their floor for a week. It was very cocoon-like. My parents would make me Japanese-style home cooking and we would sit around this little card table with my ex-boyfriend, drink soup, and hang out. It was like being a kid again in this strange way, a bizarrely nice moment to just be with my family. If this accident hadn't happened, I wouldn't have had this time with my family and my ex, and he and I wouldn't have had a real reason to be in touch again.

In the fashion industry, it always feels like if you're not present for every event, you're going to fall behind. What I learned through this accident, though, is that if you step away for a moment, it's totally fine. When I returned to work I was a little more interested in taking care of myself. Getting that concussion made me realize that when a challenging life moment happens, the person I wanted to have around me, other than my family, was my ex-boyfriend, now husband.

Every once in a while, something changes and the people who matter and the way you need to take care of yourself are instantly apparent. Otherwise, it's so easy to get wrapped up in everything you're doing, going from thing to thing, unaware of the ground beneath your feet.

—AS TOLD TO EMILY SPIVACK

Aya Kanai has been chief fashion director at *Cosmopolitan*, *Seventeen*, *Good Housekeeping*, *Redbook*, and *Woman's Day*, and is a judge on *Project Runway: Junior*. She is a native New Yorker who currently lives in Brooklyn.

BARBARA
HANSON TREEN

When you go inside a prison, monotony and hopelessness overtake everything. The inmates' personalities are hidden because they are all wearing the same uniforms. The officers are all dressed the same, too. It's dreary, it's drab, it's deadening.

I worked for five years at Rikers Island, mostly with female prisoners, doing investigations for the New York City Board of Corrections and trying to secure alternatives to incarceration. That led to a job at the New York State Parole Board from 1984 to 1996 where I went to all seventy-plus New York prisons in operation. (Someone once figured that in my time on the board, I helped make seventy-seven thousand parole decisions.) After I'd flown home on one of those little puddle jumpers from the New York correctional facility I'd visited that day, I'd be walking down Eighth Avenue, thinking of the many lives sitting in those prisons. It gave me an appreciation for my own fortunate life.

I was spending a Saturday shopping with my mother when I got this coat. Being constantly on the road for work didn't give me much time to spend with her, so we did these shopping days, which were always fun. My mother would call this *shpatziring*, which in Yiddish means "window-shopping" or "hanging out."

My mother was very proper and had exquisite taste. She saw this coat at one of those showroom sales you'd find out about from a guy handing out flyers on the street, and she wanted me to have it. The coat was in direct opposition to the self-censoring I practiced when selecting what to wear to work in the prisons. It was a zinger, a showstopper. We both understood that while the coat wouldn't catapult me into a profession of happiness (I felt very privileged to do the work I was doing), it was a reminder that there was also gaiety and hope in the world.

At the time, I was between marriages, with two small children, and didn't have much money, so she bought it for me. My mother was always rooting for me, even though she was not one to give compliments. After she died, I was looking through her purse—and

this still makes me cry—I found a cut-out ad that she had run in a Hadassah journal and carried with her. In the ad, she said how proud she was on the occasion of my appointment to the parole board. I was stunned. She also rooted for my social life. Her buying this coat for me was her way of saying, "You're going to look great when you go to the Plaza!" She thought it would help me settle down. Settling down to her meant getting married and living happily ever after.

I came into my work as a feminist, and I paid special attention to staying true to my female instincts. I was a criminologist and a clotheshorse. My work environment was a male bastion, and the women who worked in it got their street cred by being tougher than the men. But I brought in a new dimension, a nurturing way of doing business. Everybody laughed at my expense as a woman in the system, because I wanted to change the world and then decorate it. In fact, at Attica, I once asked if we could have flowers on the table when we conducted parole hearings. If you treat people with dignity and respect, you will get dignity and respect in return.

—AS TOLD TO EMILY SPIVACK

Barbara Hanson Treen is a former New York State parole commissioner and the author of *Geranium Justice: The Other Side of the Table*. She lived in New York from 1960 to 2003 and currently lives in Ogunquit, Maine, where she grew up.

BEAUREGARD
HOUSTON-MONTGOMERY

Innately androgynous, I focused from an early age on fashion as an expression of my genderqueer nature. I would always seek designs that I felt transcended gender completely, and *fabulously*. As my parents decided to (at least superficially) ignore this, I was left to draw my own conclusions. I took anyone's disapproval of my look as a sign that something was wrong with them, and not, to quote Anita Loos, with "a girl like I."

At seven, I absorbed two films that showcased androgyny via Hubert de Givenchy's couture costumes: *Funny Face*, starring Audrey Hepburn as gamine Jo, and *Bonjour Tristesse*, starring Jean Seberg as soignée Cecile. The films were an epiphany, as were the incredibly chic images by photographers Mark Shaw in *McCall's Magazine* and Bert Stern in *Look* magazine. One photograph of Lee Radziwill wearing a tunic from Yves Saint Laurent's Dior design period in the early 1960s (taken by Mark Shaw) struck me as the most classic (and classy) example of the androgyny I so admired. The design inspired me so much that from then on, I envisioned myself living in Manhattan, wearing exactly what I liked, and having everyone worship me for it.

As no closet could possibly contain me, by my late teens I had escaped my bleak Missouri adolescence and was indeed living in New York City transformed into my own five-foot-eight, 105-pound, completely queer version of Audrey's Jo and Jean's Cecile. The street was my runway. Whereas only a few months before my arrival I could have been arrested for mixing and matching garments of both genders, the Stonewall Riots ensured that at least the police wouldn't harass me.

This was the 1970s; hypnotic pharmaceuticals were given out like candy, the streets were plastered in porn, and inhibitions were at an all-time low. Add to this the righteous indignation of the unmedicated. I was once banned from a Madison Avenue bus because my hot pants were "too short"! One afternoon, while walking down the street minding my own business in a Betsey Johnson tunic, I was accosted by a drunken Otto Preminger,

the director of *Bonjour Tristesse*, for not shaving my legs. And, of course, I daily endured "Where are your tits?!" from a construction worker, until I finally decided to set him straight; naturally, he turned out to be a needy bottom.

I became part of a dazzlingly diverse, highly creative, loosely connected group of individuals who liked to mix and match old and new, fantasy and reality, male and female. For a fleeting time, maybe a year or more, many would congregate on Sundays in Central Park, where everyone would circle the Bethesda Fountain in a Fellini-esque frenzy.

I loved mixing vintage and utilitarian items—for which New York City was a treasure trove—with expensive creations, which I usually found at Henri Bendel, one of my all-time favorite shopping emporiums. The original Bendel's was streamlined and subtle, and exquisitely prescient; in other words, *the chicest*. A dwarf doorman in full livery named Buster (not that we were on an any-name basis) would open the door and let you in and out.

Designer Stephen Burrows had an extraordinary boutique at Bendel's, where one day I became transfixed by a pair of wool pleated pants, patterned with big balloons. By this time my salesperson and I were well acquainted. A rather quirky young socialite, who could only have worked at Bendel's, she sensibly talked me out of the pants with, "Your butt is simply not big enough for those pants; let's bring out the Castelbajac!" And so she produced one of my favorite items of clothing: this wool tunic by Jean-Charles de Castelbajac so very reminiscent of Princess Radziwill's YSL/Dior.

I immediately wrote a check for the tunic, reminding my consumer comrade to remove the alarm tag (because she always forgot), which she did on the spot.

My parents, who were at best upwardly middle class, were thrilled to have me out of sight, and had given me my own checkbook, so I wouldn't starve or embarrass them any further. It gave my complex mother vicarious pleasure that I should be dressed well, if inappropriately.

I noticed Buster was on a break as I sashayed toward the front doors, dressed that day in a black hooded Kenzo tunic, red skintight jeans, huge YSL sunglasses, orange Rive Gauche ski cap, and gold Capezio jazz shoes. Two package-laden, fox-furred ladies leaving ahead of me opened one of the front doors and walked out, with me behind them. As they did, an alarm went off.

Assuming I was the culprit, the guard immediately grabbed my shopping bag. Shocked, I turned and gave him "The Look"—an ice-cold, fiercely focused stare, perfected in childhood from seeing *Village of the Damned*, and desperately desiring to join that deadly and blonde-bewigged gang of alien fashionables.

The guard said, "Please wait," and ran off with my bag. I then took a seat at the "information" (a.k.a. detention) booth near the entrance, where he sat. There was a phone, so naturally I picked it up to get some 1970s social media going.

Immediately an employee appeared and screamed at me to get off the phone. "Pardon me, bitch," I said matter-of-factly, "I'm calling my lawyer." She quickly disappeared, and the guard returned, handed me my shopping bag, and asked me to please go to Geraldine Stutz's office. Geraldine Stutz was the tough-as-nails boss and brilliant brains behind Bendel's.

I took the small, creaky elevator up to her office. The lift was crowded and included a suntanned, outgoing little man who informed the assembled that he was about to show Stutz his new hand-painted line of vintage-style hula neckties.

Stutz's blonde female assistant told the hula man, Ralph Lifshitz (later, Ralph Lauren), to wait, and quickly ushered me into Stutz's small, no-frills office. Geraldine Stutz was sitting behind her desk, holding up my check, which she proceeded to tear up. "This should not have happened. Have a glass of champagne." With that, she poured me a glass of Cristal, no less, which I gulped down in complete shock. I bolted out the door before she changed her mind, only to encounter the blonde assistant being cornered by Mr. Lifshitz, who was clearly determined to show somebody those trendy ties.

I immediately ran back to my consumer comrade and wrote another check for a Castelbajac jogging ensemble I couldn't possibly have afforded earlier. As I sashayed out a second time, with *two* coveted Bendel's shopping bags, Buster was back and I was emboldened to make eye contact, along with my usual thank you, as he opened the door.

Outside, a garbage truck pulled up with perfect timing. One of the garbage men, my friend Vinny (I always called him *Vincent*), shouted out, "Hey, fancy pants, we're going down to the Village, need a ride?" To Buster's detached bemusement, Vinny's colleague, Dominick, hopped out and lifted me and my Bendel's bags into the passenger side of the looming vehicle and off we went.

Beauregard Houston-Montgomery is a writer, photographer, and avid dollhouse collector. He has lived in New York since 1970.

BEN
BOSTIC

I had been prepared to die, bracing for impact, knowing the plane was going to crash. I got real calm. It was like, "OK, I have no control over it." The scariest part had been watching the left engine burn and waiting for the outcome. After we landed on the Hudson, I remember flipping my hands over, wiggling my fingers, and looking down at my feet. I was shocked that I was still in one piece.

When the water started coming in, I noticed it almost immediately. The hole that had been ripped into the plane was behind me. We were tilted backward, which meant that water was filling up the back of the plane. My boots were already soaked. It was up to my ankles. I naively thought, "That's no big deal," assuming that it wasn't coming in too fast.

Then my mind switched gears. It was time to get out of there. I thought, "What do I need to do now?" I heard people unbuckling their seat belts. All this chaos was going on around me—people trying to figure out what to do, the crew and passengers working together to help the few children on the plane, an elderly lady, and a flight attendant with a pretty bad cut.

Time slows down when your adrenaline is pumping. I realized, "Oh my God, the water is up to my knees now." My jeans were soaked. It was freezing cold but my mind was like, "I don't care. I'm alive."

I was in the twentieth of twenty-six rows, and the flight attendant in the back of the plane was saying frantically, "Move forward, move forward!" because the farther back in the plane the deeper the water was, and it was cold. In the six rows behind me, people were in waist-deep water, up to their neck, even, before they could move forward. You couldn't stay in there long. You'd get hypothermia. We had to get out fast.

There was a huge bottleneck. The flight attendant said, "Go over the seats, do whatever, we just have to move forward." A lady was climbing over empty seats in front of me. I

followed her. I realized I hadn't grabbed my life vest, which wasn't very smart, so I grabbed a seat cushion.

People were trying to get out of the doors over the wings, but they were crowded. I noticed that the aisle was clear in the first ten rows, and there was no water in that part of the plane yet. The flight attendant by the front doors was motioning people to come in that direction. She told me to jump into the raft and I jumped. We were crammed in there like the most crowded New York City subway, but it was OK. I was alive. I could handle it.

When the ferries got to us, the people on board started throwing us life preservers. We put them on until we could get out of the raft and onto the ferry. Once I got on board, I realized the people helping us were ferry passengers, just bystanders on their way to work. They were literally giving us the clothes off their backs, directing us to a heating vent to warm up, trying to give us their gloves.

The Red Cross was waiting for us at the ferry terminal once we arrived. They were handing out these old-school, George Costanza–looking blue crewneck sweatshirts and sweatpants that matched. Everyone was grateful for them. They offered them to me, but I was good. My pant legs had started to dry, but my shoes and socks were soaking wet. They had slippers, like the ones a hotel would give you, but I kept my shoes. I took the dry socks they offered me.

I remember all the steps. First, get me off the plane. Then get me out of the raft and onto the ferry. Then, get me to shore so I can put my feet on land. The next step was figuring out how to get home to North Carolina. The last thing I wanted to do was get on another plane. Nevertheless, that evening, a few of us caught a flight out of Teterboro. It was about one in the morning before I got home and took off those wet shoes.

All of us needed rescuing, from Captain Sully on down, and the people of New York were the rescuers. New York came to our aid in full force, and it reaffirmed my faith in humanity. I was jaded before that. I had seen some bad things, abuses of the system, especially when I worked in EMS fire and rescue years ago. But this incident brought out the best of humanity, and it had a lot to do with New York. Seeing how organized the FDNY, NYPD, and Coast Guard were, and the sheer amount of people who turned out, blew my mind. I don't think the rescue mission would have been as successful anywhere else.

That had been my first trip to New York and it had almost been my last. I got another chance at life. Now I have this bond with the city, and since that first trip, I've been back many times.

—AS TOLD TO EMILY SPIVACK

Ben Bostic is a software executive and a survivor of the US Airways flight 1549 crash landing in the Hudson River. He lives in North Carolina.

BENJAMIN
LIU

As Andy Warhol's studio assistant, most days I'd work with Andy at The Factory all day and into the evening. In the morning, I'd pick him up at his place on Sixty-Sixth and Madison and spend a couple hours doing personal stuff for him, maybe going with him to doctors' appointments. I'd take care of getting his photographs organized, developed, and printed. I'd sit in on interviews for *Interview*, I'd help with his TV show. I'd accompany him to social events, lunches, meetings, parties. It was endless.

I'd head to work wearing jeans, since everyone was wearing jeans at The Factory then, and a black polo shirt. We all wanted to match with Andy. After work, I'd go back to my apartment in the East Village and change my outfit. For my nighttime personality, I would dress up to go out. I loved wearing a pair of Vivienne Westwood shorts with this Vivienne Westwood tank top, which I had in three colors—blue, black, and green. It was one of my favorite outfits to wear to Area, the nightclub I frequented three to four times a week for a few years, beginning in 1983.

When I'd arrive at Area, I'd go straight to the bathroom. The men's or women's bathroom was always the place to be, the real VIP lounge. It was the unspoken spot for those who were in the know, and it was always the first stop you'd make to say hello to everyone.

Sometimes I'd go with Andy to Area. Usually after a little while he'd say, "I'm leaving now." I'd put him in a cab and stay longer. I don't know how I did it in those days. I worked hard and stayed out late.

A strikingly handsome dancer named Desmond was the social arbiter of the men's bathroom. He would also sell cigarettes. There were nights when I would ride over to Area in a taxi—how frivolous—just to buy a pack of cigarettes and hang out in the bathroom. I wouldn't even go into the main club, because everyone was in the bathroom. Other times, I'd get a drink at the bar and head back to the men's room. In those days, Tony Shafrazi,

Keith Haring, maybe Larry Gagosian might be around, and these kids who we called "nameless kids." They were the real stars of the scene.

There was a ridiculousness to the bathroom, a fun-ness, an outrageousness. Things were invented in that bathroom. Like snapping your fingers and saying, "You go, girl!" One of those nameless kids came up with that. Sometimes a straight couple would be having sex in a stall in the men's bathroom while we were hanging out, and we'd get up on a stool and look in—you know, stuff like that. And so much fashion happened in there, too. People would be wearing Vivienne Westwood, Stephen Sprouse, clothes from club kids who were also budding designers. Or people would be wearing their own creations.

Area was fascinating because it was the only club in New York opened primarily by artists, an art gallery-slash-nightclub. It had a theme that would change every six weeks, and artists were invited to do the windows. Andy did a window called *Invisible Sculpture*, but I didn't work with him on it—there's not much work you can do on an invisible sculpture!

One time, I decided to host a party for Jean-Paul Gaultier after his first American fashion show at Bergdorf Goodman. That same night, Andy decided to set up a Polaroid studio in the women's bathroom to shoot the most interesting, creative people in New York—not celebrities—for the Italian magazine *Mondo Uomo*. Even though I was hosting this party, he said, "You're my assistant tonight, too. You have to pull people to photograph." One of the people I pulled for Andy was Stephen Gan, the cocreator of *Visionaire*. He was wearing a Gaultier men-skirt, which had just been introduced at that New York show, and his look was brilliant. "Come with me," I said. I pointed to Andy. "You're going to be photographed by him."

—AS TOLD TO EMILY SPIVACK

Benjamin Liu is a former studio assistant to Andy Warhol and is currently a student. He has lived in New York since 1978.

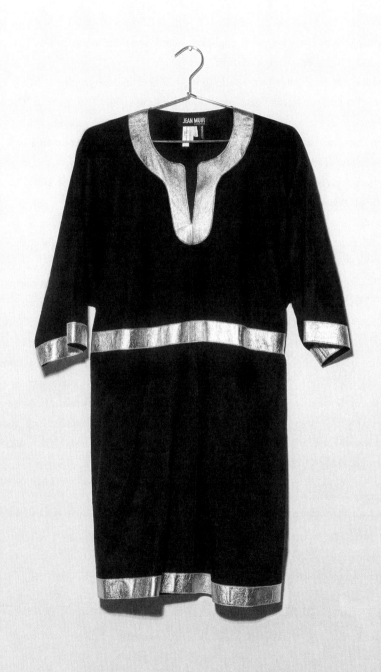

BETTY
HALBREICH

The last time I wore this dress I had been invited to my good friend Edward Bess's thirtieth birthday party, in December 2015. We've been friends since he was nineteen years old and I was seventy-six. I picked him up in the beauty section of Bergdorf Goodman. He was always standing very erect, showing off his line of lipsticks. I went up to him one day on my way up to the third floor, where my office is, and said, "Do you ever sit down?" And then I said, "You're the most handsome, beautiful man I've ever set eyes upon."

Edward had his birthday party in a lovely narrow room at the Beatrice Inn. It was a very chic party. The photographer Ruven Afanador had artistically "stuffed" the most extraordinary flowers into vases and the food was divine. For dessert, there was a surprise appearance by Joey Arias. I had two vodkas and rushed over to Joey to say, "I'm one of your biggest, oldest fans. You have the saddest eyes I've ever seen." He was so taken aback that nothing came out of his mouth.

It takes a lot of nerve to wear this black suede and gold leather Jean Muir dress. It had been hanging in my closet, but I hadn't worn it in twenty-five years. You have to be pretty secure, and I'm not that secure. I don't use a computer or a cell phone. I don't add or subtract. I feel very inadequate at times. I live in the spoken word and eyeball-to-eyeball world doing what I do at Bergdorf's. But for Edward's party, I got all dressed up. I wanted to look good for him, but I also didn't care how anyone thought I looked.

I loved wearing this dress on such a happy occasion and I can't wait to wear it again. I just walked by my closet the other day and fondled it. It's the strangest thing. I looked at it and said, "I really love you."

—AS TOLD TO EMILY SPIVACK

Betty Halbreich, author of *I'll Drink to That: A Life in Style, with a Twist*, has operated her personal shopping business, Solutions by Betty Halbreich, out of Bergdorf Goodman for over forty years. Born in Chicago, she has lived in New York since 1947.

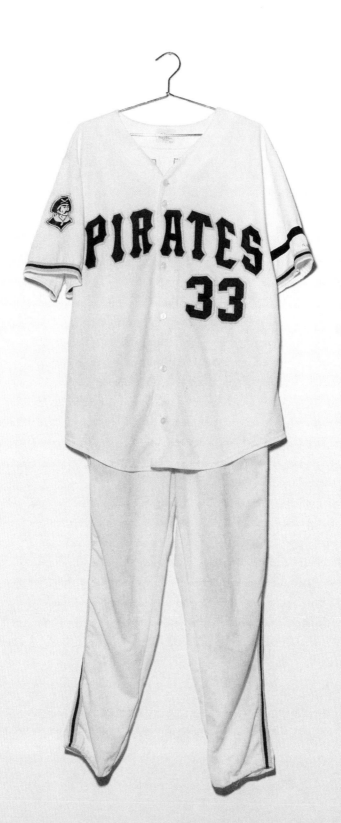

BILLY GONZALEZ

Like most immigrants, I came to the United States because my mom wanted to have a better life. I arrived in New York from the Dominican Republic in the winter of 1983 when I was sixteen. It was cold and ugly. I wanted to go back the same day I arrived. I told my mom, "My dream is not here. How am I going to play baseball?" Since I was a little kid, my passion was to be a baseball player. But I stayed because I wanted to make my mom happy.

I tried out for the Yankees and the Mets in 1986. I never got signed, because I'd broken my leg. I had been hit by a car a year earlier and my whole life had changed. I had good power, good hitting, I had almost everything, but the main reason they didn't sign me was because of my leg.

This uniform is from the last time I played baseball twenty years ago, when I was playing in the Crotona Park league in the Bronx, the best minor league in New York City. We played two to three games per week each summer. I played third base. I was playing with my heart, but my leg never entirely healed. Every baseball player knows when their body isn't working the same way, when they're not seeing the ball the same way—they know when they need to retire. I knew it was time to go.

I decided to run my own business. I started my deli with $100 in 1998. The guy who had the deli before me was probably very tired. He told me to pay him $100/week for five years to take it over. I gave him what I had in my pocket and I got the business. This is my passion now. I love this business like I loved baseball before. I work almost every single day, twelve hours a day. As soon as I arrive in the morning, the only thing I think about is the business.

Every penny I made, I put back into the floors, the ceiling, the walls, the equipment, redoing it little by little. I had this crazy guy paint the night sky with a coyote on the ceiling. The nighttime is so beautiful when there are a lot of stars and this glow from the sky. I wanted everybody coming into my store to look at the sky.

I work here with my wife. She works in the kitchen and I run the front. She was originally a customer. She liked my sandwiches. She was on vacation from the Dominican Republic and she came to the store and ordered a chicken sandwich. She came back for another one the next day and I decided to give her my number. I told her to call me at 10 P.M. And she did. She returned to her country and we talked on the phone every single day. Then she came back to see me, and we have been together ever since. I had been feeling lonely and depressed because I had gotten divorced and my kids were living with their mother, but I said, "God, please send me a beautiful wife," and he did.

I've been in this neighborhood for thirty-five years. I see a lot of things, good and bad. Every night at 10 P.M., we give away the food we don't sell, because we want to keep everything fresh. Usually between twenty and twenty-five people come by. Sometimes, people will come in and say, "Billy, you might not remember, but I was in that line looking for food and now I'm good."

One time my son, Jonah, when he was ten years old, asked, "Daddy, why are these people always in line?" I told him it's because we give away anything we don't sell. I told him, "It's better to give than to receive because every time I give to anybody, I feel good." Later, my son told me one of the kids at school said that he didn't have money to buy lunch, and his mind went back to what I said about helping other people. Even though he was hungry, Jonah gave money to the other boy. I told him, "You've done the right thing." That day, I cried—not in front of him—because he had listened to me. I feel lucky. I have my family, my kids are proud of me, and there's nothing better than that.

—*AS TOLD TO EMILY SPIVACK*

Billy Gonzalez is the owner of Billy's Deli in the Bronx. He grew up in the Dominican Republic and has lived in New York since 1983.

BRENDA
BERKMAN

I have this photograph of myself and a group of girls who were all editors of my high school's newspaper in Richfield, Minnesota, dressed in the boys' baseball team uniforms. To most people, that photo was a spoof or joke, but to me, it was serious. It was an example of what I wanted to be, but couldn't be, because I was a girl. Throughout my childhood I had been a tomboy. My mother had signed me up for Little League because I wanted to play baseball. When the coach found out I was a girl, he turned me down. So the idea of wearing a uniform, especially a uniform to play a sport, got stuck in my mind as something honorable and desirable.

At that time, girls were told they had very limited career options—a teacher, a nurse, or a secretary. The idea that women could be doctors or even attorneys seemed very remote. Job ads in the newspaper were gendered—jobs for men and jobs for women.

One summer after college, I worked in my late father-in-law's law office while he was representing women of the NYPD in a sex discrimination case. I wondered whether I should go to law school and put into action my desire to achieve equality for women, especially in the workplace. It was the days of Betty Friedan, Gloria Steinem, and Robin Morgan. Billie Jean King was making statements about equality for women in sports. There was a lot happening for the feminist movement.

I went to law school at NYU in 1975 and sat next to a guy who was a fire buff. A fire buff is someone who may or may not be a firefighter but knows everything about the fire department. New York had a lot of big fires then. He was going to places where fires were happening and he would tell me about them. Meanwhile, my husband at the time had gone into his father's firm, and they represented all the fire officers in the city through the Uniformed Fire Officers Association. I saw how much these firefighters loved their jobs.

Around then, I started running marathons and I'd gotten into pretty good physical shape. And I thought, "Wouldn't it be great if I could become a firefighter and serve my community that way?"

In 1977, when I was in my last year of law school, the firefighter test opened to women for the first time. I say that with a smirk because that was the same year the city decided to develop a new physical abilities test for firefighters. The man in charge of the test for the City Personnel Department said it was the most difficult test they had given for any job in the history of the city.

In 1978, I passed the written portion of the test. I showed up at an armory in Bed-Stuy to take the physical test, which I'd trained for by doing things like carrying my husband up and down stairs, because of this so-called dummy carry we'd have to do. I failed that exam. Not a single one of the ninety women who had passed the written exam passed the physical one.

I needed to do something about that. None of us were asking that standards be lowered merely because we were women. We were asking that the standards be job-related and that women be given a fair opportunity to meet those standards. I sued, maintaining that the exam was not job-related and that it discriminated against women. About four years later, I won the lawsuit.

Even at the beginning of my career, my fire department uniform symbolized my right, and all women's right, to be a firefighter. And it became even more meaningful because less than a year after I was hired, the city fired me and another woman for lack of physical capability, which was insane. By all fire department measurements, I was the number one, two, or three in every task they'd given women to do.

I had to go back to my firehouse, Engine 17 on the Lower East Side, where the men would not speak to me or eat with me, and listen to them clap when I left. I had to empty my locker and return all my protective gear to the fire department. I was not allowed to wear my dress uniform anymore, because I was fired, which was unbelievably hard. That was in 1983. Later that year, we sued to get our jobs back, and in December of that year, we won the lawsuit. I got assigned to a new firehouse in Harlem.

I have been awarded three citations, which are on my uniform. One was from my time with Engine 17 when we had a tough fire in a tenement. It was a big deal that we got written up, but the guys I worked with actually wanted to turn it down because I was on the citation. So that's on my uniform. Another citation is for a construction collapse in Chelsea when I was a lieutenant. We went above and beyond the call of duty. And I got a citation for being at the World Trade Center on 9/11. I was off-duty that day, but a small group of off-duty firefighters including myself got there just as the second tower, the north tower, fell. We worked late into the night, came back the next day and worked late into the night, and on and on like that. This is my captain's uniform. I was promoted twice and was a captain when I retired after twenty-five years with the FDNY.

Most people still don't realize that women are firefighters. A lot of people don't even know the correct terminology—they want to call us "lady firemen" or "fire belles" or other ridiculous names. This uniform gives me the opportunity to talk to people in a nonthreatening way about their attitudes toward firefighters. And believe me, when someone shows up in your burning apartment to drag you out into the hallway, you're not gonna be in any condition to say, "I'm sorry, I only want to be rescued by a male firefighter."

I'm proud to be part of a profession that the public regards with great respect, even though I don't agree with what some people in the fire department do. A lot of the traditions are racist, homophobic, and sexist. But in general, I am part of a tradition that's self-sacrificing and service-oriented—in the middle of the night, in all weather, twenty-four hours a day, 365 days a year. And it's a way of serving your country without having to shoot people, which appealed to me a lot. My parents raised me to believe that you are not put on Earth just to take up space. My uniform is emblematic of my philosophy that people should try to leave the world better than they found it.

—*AS TOLD TO EMILY SPIVACK*

Brenda Berkman brought a sex discrimination lawsuit against the FDNY that resulted in her becoming one of the first female firefighters for the Fire Department of the City of New York. She has lived in New York since 1975.

CATHERINE
OPIE

I'd moved out to Novato, California, after undergrad because this girl I knew had just inherited her grandparents' stucco house in the suburbs and needed a roommate. In the closet of my new bedroom was this mint condition 1952 Sears, Roebuck and Co.'s leather jacket. I tried it on and it fit me like a glove. My meth-head roommate bequeathed the jacket to me, and it was the first piece of clothing that allowed me to identify as a leatherdyke—it was hot and sexy and transformed me from a girl from Ohio into an urbanite. I needed it to feel like I could fit in. Even though I was definitely playing in the leather community, without the right accoutrements, you're not a real player—you need to own the coolest leather jacket or the best whips, or the best dildo harness, or whatever the things are that signify you as part of this community. I liked thinking, too, that the person who wore it before me was probably a straight white suburban man in his fifties and that wearing it was his way of looking tough, as if he rode a Harley. Also, it was the only warm jacket I owned, so I packed it whenever I went to New York or anywhere chillier than San Francisco.

On one of those trips, I was in Toronto at a dyke bar wearing the jacket when I met this woman, Anna Marie, a photographer whose work I admired. She and I wound up being lovers and for the next couple years we would meet in New York City, since she lived in Toronto and I lived in San Francisco.

I was wearing the leather jacket one New Year's Day when Anna Marie and I went looking for the ball that had already dropped, thinking we could find it somewhere in Times Square. Times Square in the mid-1980s was all X-rated movie theaters with the bizarre old army recruiting station in the middle of it and was utterly unapologetic for the way it occupied its space—the good, the bad, and the ugly.

Mostly, Anna Marie and I would seek out our own private New York adventures— finding pot at Washington Square Park, walking through Times Square, staying in cheap,

run-down hotels that we would turn into dungeon environments for ourselves. And we tried to have as much public sex as possible—train stations, alleyways, public restrooms. We were young and dumb and horny and acting tough, invincible, and slightly irresponsible. Wearing that leather jacket around the city, I wasn't trying to get the attention of anybody. I was inhabiting my own identity, my own butchness, and having a hell of a good time.

—AS TOLD TO EMILY SPIVACK

Catherine Opie is a fine-art photographer whose work has been exhibited at the Guggenheim Museum, New York, and the Museum of Contemporary Art, Los Angeles. She lived in New York from 1999 to 2001 and currently lives in Los Angeles.

COCO
ROCHA

I have been a huge fan of Elizabeth Taylor ever since I watched *National Velvet* as a child. When my friend invited me to the Christie's auction of Elizabeth Taylor's clothing, I jumped at the chance. I didn't think I would be able to afford anything, so going into the auction my hopes weren't high. I'd gone through the catalog beforehand, which listed her wedding dress, headpieces, and muumuus, but one piece stood out. It was different from what she usually wore: an awkward yellow and hot pink Givenchy jumpsuit from the 1970s or 1980s that reminded me of *I Dream of Jeannie.*

When that item came up for auction, I put my hand up and maybe one or two other people did as well. And suddenly, it was mine. I was the youngest person in that room, and all these older women turned and looked at me. One asked, "What are you going to do with that?" I'd heard that these women just buy the garments and keep them in glass containers. They would never wear them. I looked at the women, confused. "I'm going to wear it. Isn't that why we're here? To say that we're wearing an Elizabeth Taylor piece?"

The Met's exhibition *Schiaparelli & Prada: Impossible Conversations* was the theme of the Met Gala in 2012. I thought the jumpsuit would be perfect to wear on several levels. Its vibrant colors aligned well with how Elsa Schiaparelli used vibrant pinks. It was the ultimate conversation piece. And it embodied my own impossible conversation, the one I wished I could have with Elizabeth Taylor. I channeled that imaginary conversation and decided not to tailor the jumpsuit at all. It had a very tight waistline and was maybe a little too big in the chest area and too short in the legs, but I didn't want to touch it. This was exactly how she wore it.

I didn't realize when I bought the jumpsuit that there was a huge red wine stain on the jacket. Since it had already been laundered, I knew the stain wouldn't come off. It was genius that Elizabeth Taylor had spilled wine on it. It wasn't a piece left unworn in her closet. While I never found a photo of her wearing it, I believe she did, because of that stain.

Before I went to the Met Gala, I wrote on social media that I was wearing this piece and invited people to tell me if they could find the wine stain. On the red carpet, instead of hearing reporters yelling, "Coco, Coco, come here! What are you wearing?" I heard, "Where is the wine stain? Where is the wine stain?" They already knew the story.

I come from a little city in Canada where going to an auction to buy an Elizabeth Taylor piece is not something I ever thought could happen. I wanted to share it with the public, especially because I knew you'd never get to see the pieces those other women bought at the Christie's auction. Even if it had extra space in the bust, even if it was cropped in the legs, even if it was cinched in at the waist, it was her body shape, and I wore it just the way it was.

—AS TOLD TO EMILY SPIVACK

Coco Rocha is a fashion model who lives in Toronto, Canada.

DAVID
BARTON

More than ten years ago, my friend, the artist Kenny Scharf, silkscreened a few pairs of jeans for me. I was wearing one of them when I went to my son, Bailey's, parent-teacher conference at Saint Ann's in Brooklyn. I was getting a progress report when I saw his teacher staring down at my pants. She looked like she'd just smelled rotten cheese. I was like, "What's she staring at?" What I hadn't noticed until that moment was that the jeans had been screen printed with hardcore graphic porn. I'd been wearing this pair of jeans for a couple of months already, and I had never noticed the pornographic images from what looked like a 1960s Italian comic book. No one had noticed—except for my son's teacher, who was looking at me like, "How could you walk into a school wearing X-rated clothing when there are little kids running around?"

I was both horrified and a little defensive. I was thinking, "Hey, listen. I know you're looking at my pants, but you're the only one who ever noticed it's porn, so don't look at me like I'm some kind of perv!" Later, I called Kenny and said, "You put porn on my pants!" He was like, "Yeah, I know! Isn't it great?" And I was like, "No! I went to my son's school wearing them!" And he was like, "Well, why'd you do that?"

My wife, Susanne Bartsch, and I already stood out at Saint Ann's amid lots of architect dads and soccer moms. I didn't look like your typical dad who wore a dad sweater over a little paunch. My son would tell us he knew when we arrived at school, because the kids liked talking about the unusual parents.

His friends also liked coming over to hang out. We lived at the Chelsea Hotel, a floor below Dee Dee Ramone, and Bailey's bedroom was what had been Janis Joplin's apartment. My wife was working as an event producer out of our apartment, so there was a regular procession of club kids, drag queens, and DJs hanging out. Bailey got along with all of

them. When he was a little kid, I'd put him on my shoulders and we'd go out to nightclubs where Susanne was hosting a party. We'd walk through the club and people would yell "Bailey!" and high-five him.

So when I told my son about the jeans and what had happened, he just rolled his eyes, and was like, "Oh, Dad . . ."

—AS TOLD TO EMILY SPIVACK

David Barton founded David Barton Gyms in 1992 and TMPL Gym in 2016. He has lived in New York since 1980.

DEBORAH
BERKE

When it rains in New York, it's horrible, period. It's as though people have never seen rain before and they don't quite know what to do. You have to look up to make sure no one hits you with an umbrella. You have to look down to make sure you don't step off the curb into a two-inch-deep puddle. It's just . . . an assault. It rains everywhere, what's the big deal? But rain in New York is a particular insult. I'm saying this as a lifelong, multigenerational New Yorker. It's worse than snow.

I wear a hat when it rains rather than carry an umbrella. I've had this one from Worth & Worth for more than twenty-five years. I know because I bought it right before I got married and this year we celebrated our twenty-fifth wedding anniversary.

My husband, Peter, and I grew up in the same neighborhood in Queens. We met when I was ten years old. We were friends for twenty-seven years—pen pals, actually—before we got married. I went to RISD to study architecture. I knew cool people. I hung out downtown. All my boyfriends were starving poets. Peter was pre-med, a total straight arrow, an athlete. We were buddies. I knew all his girlfriends and he knew all my boyfriends. One year, though, when we were well into our thirties, he wasn't dating anyone and I wasn't dating anyone. We went out for Chinese food, which we would have done even when we were with other people—as I've-known-you-forever friends. That night, though, he asked if I'd like to go back to his apartment, and I thought, "If I sleep with this guy, I'm either going to marry him or it'll be the end of our twenty-seven-year friendship." Six months later we were married.

A few months before we got married, I wore this hat out one night with Peter. At the time, I had an Annie Hall look—thrift store vests over old cashmere sweaters with jeans, work boots, and, you know, my hat. The night was stormy and the hat blew off my head into the middle of the street. A taxicab drove over it. It didn't quite have tire marks on it like in the cartoons, but it got crushed in the pouring rain. Peter ran out into the middle

71

of the street and got the crumpled, rain-soaked, slightly oily hat. It was a chivalrous move. We took it to the hat doctor on lower Fifth Avenue together. It was early in our romantic relationship but well into our almost three-decades-long friendship. It felt like a project, like buying a couch or getting a dog—everything was great because we were doing it for the first time together. They cleaned it, steamed it, and reshaped it.

I treat the hat rudely and inappropriately, but I'll never lose it. It doesn't live in a hat-box; it just sits on a shelf in my closet. On a day that's cloudy in the morning and forecast to rain later in the afternoon, I kind of fold it in half and smoosh it into my bag. When it rains, I pull it down over my head to make it look like a bowler, even though it's not meant to be worn that way. And then it gets rained on and takes on that nasty smell of wet wool.

The fact that this hat had this traumatic experience, almost like a living thing—my not-yet-husband running out into the middle of the street to rescue it, us taking it to hat rehab—makes it a meaningful part of my life. I may treat it poorly, but I'll never forget it.

When I was younger, the hat looked cool, but now I look ridiculous pulling it down over my head to give it shape. Peter still loves it. He thinks I look cute in it. I try to look like a creative elegant person in my mostly black clothing and tailored look. And then I put this damn hat on because it does the job.

—*AS TOLD TO EMILY SPIVACK*

Deborah Berke is the founder of the New York–based architecture firm Deborah Berke Partners and is the dean of the Yale School of Architecture. She was born in Queens and lives in Manhattan and New Haven, Connecticut.

DICK
CAVETT

I didn't know it would turn out to be a notorious night on *The Dick Cavett Show*. My guest was the author and critic Mary McCarthy. And she rated Miss Lillian Hellman as the most dishonest writer she knew. The notorious line that has come down through the ages was, "that every word she writes is a lie, including 'and' and 'the.'" The next morning, Miss Hellman called and asked, "Dick, why the hell didn't you defend me?" I said, "Well, Lillian, I never thought of you as someone who couldn't defend herself." She was sore as hell and, if you're old enough to remember those days, she sued me, PBS, and Mary McCarthy. The old bag now had three lawsuits to munch on between endless cigarettes and shots of the hard stuff. The thing reached scandal proportions in the world of letters. Much ink was spilled, almost all against Miss Hellman—Norman Mailer, Gore Vidal, and William Buckley wrote nasty pieces about her. But she persisted in her folly, bringing Mary to her knees financially, and it all ended in a big bad mess.

On the show, I had a dresser, a lovely man named Michael Scrittorale, who would lay out my clothes. I don't give a damn about clothes and don't know what I'm wearing until someone points out that I have on two shoes that don't match—this actually happened to me once. Michael would let me know that I had a cuff link missing, a button undone, or my fly open. (Although it was Frederick Austerlitz who, as he was about to walk out onto my show, saw me struggling backstage to tuck the shorter back of my tie into the keeper loop. He said, "No, no, leave it. A little separation looks good." That man was better known as Fred Astaire. Like me, he was from Nebraska, although no one would believe it. After that, I never tucked in a tie again. How could you?)

The night Mary McCarthy was on the show, Michael had laid out a green jacket for me. I put it on and it felt wonderful. It comforted me. It was like being embraced by a warm friend. It became the only jacket I liked, and it happened to be the one that saw Mary McCarthy do what she did to Miss Hellman. And as some would say, to herself.

Years later, Brian Richard Mori wrote a play about that event called *Hellman v. McCarthy*. Someone had the idea that it might be fun to have me play myself. I read for the part and got it. (I used to joke that I was second choice for the role.) When they gave me this jacket, I assumed it was a duplicate of the one I wore on the show, but when I put it on, I could safely say, this was it. I was transported back thirty years, and talk about déjà vu. I wore it throughout the run, the only piece of clothing I've ever had affection for.

One night, the air-conditioning had gone off during the show at the Abingdon Theatre. We were all sweating onstage and I took the jacket off and flung it into the wings. The show didn't go well that night. I don't want to imply that it's a magic garment out of an MGM fantasy short, but when I would get to the theater after a matinee and think, "Oh God, I've got to drag myself through this thing we just did two hours ago," putting on the jacket—and this is going to sound corny—refreshed me.

Maybe ten or fifteen years ago, I went by what had been the John Golden Theatre on Fifty-Eighth Street and it was gone. It was a shock. No more *Dick Cavett Show* marquee. No more makeup mirror where I would see Peter O'Toole and Paul Newman covertly putting those drops the oculists said should be illegal into their eyes to make them bluer. No more walking up the flight of steps behind Orson Welles, watching the pressure on his ankles because of his weight. Sadly, I can't go back to the closet full of clothes in my dressing room where my green jacket was, because the goddamn theater's been torn down. But I still have my jacket.

—AS TOLD TO EMILY SPIVACK

Dick Cavett is an Emmy–award winning television personality and the former host of *The Dick Cavett Show*. He currently writes and performs, dividing his time between Manhattan, where he moved in 1958, and Montauk, New York.

DONNA
DRAKE

I had a Cinderella story, actually. Right place, right time, all the planets aligned.

I'm from a small town—Columbia, South Carolina—and I knew early on that I wanted to go into musical theater. I got out of high school a year early, got out of college a year early, and got to New York on September 1, 1974, at the ripe old age of nineteen, equity card in hand.

A couple months later, I was auditioning at the Joseph Papp Theater, which is now the Public Theater. I don't even remember what it was for. I walked out of my audition and there was this sea of women dancers stretching, sitting on the floor, everybody smoking cigarettes because that's what we did at the time. I was so naive that I innocently went up to someone and said, "What is this?" She told me that Michael Bennett was having a private audition. I didn't know who Michael Bennett was, but he sounded important. At that very minute, the stage manager appeared and said, "OK, we're ready for the ladies." They all stood up and walked in, and I walked in with them. I crashed the audition not knowing what I was auditioning for.

It was a three-day audition, probably sixty women, and we danced for four to six hours straight. We danced a version of what I later found out was the opening number of the show, which is one of the hardest combinations out there. You have to be in great shape, your body has to be built like steel to handle some of the insane moves. And when you do it twenty-five or thirty times, you find out how strong you are. I was ready. I had trained my whole life for that moment. I just needed the universe to give me an opportunity, and darn if it didn't happen.

During the audition, Michael would ask people to sing. I would sing the only song I knew, "Somewhere Over the Rainbow." After the first day, I got a callback. I came back the next day, repeated the same process, got another callback, and returned the following day.

After those three days, I knew this was something extraordinary. By then Michael had narrowed it down to fifteen to twenty men and women. We danced and danced and then sang. I sang "Somewhere Over the Rainbow" again. After I finished, I heard this voice from the back of the theater say, "Who are you?" Instead of being a professional, I thought, "Oh, oh, I've been caught, and I'm in trouble." I started crying. Not pretty crying, but blubbering, can't-catch-your-breath crying, like a six-year-old. And then I heard this voice saying, "Oh honey, you're supposed to be here. I just don't know who you are. You didn't fill out a card." I looked to the side of the stage and the stage manager was holding an index card. They just wanted my name and phone number.

The final day of the audition, we stood on a line Michael had taped to the stage. He called certain people forward. I was not one of them. He released that front line. Then Michael came onstage and welcomed the rest of us to the workshop of what I learned was *A Chorus Line*.

Previews for the show started in March. On the second day, I arrived at the theater and stopped dead in my tracks. The ticket line was around the block. That's when I realized, "Oh boy, we are sitting on a keg of dynamite." We opened downtown on May 21, my twentieth birthday, and we opened at the Shubert Theatre on Broadway in July.

A Chorus Line was based on us. Every day, Michael would gather us in a circle where we'd just talk and talk and talk. Some of the stories were dramatic. Some were very sweet. What I like to tell people is *A Chorus Line* is two hours and ten minutes of truth. One line from the show might be from one person's life, another line might be something someone else said. All of our hearts and souls are mixed up in there.

I was the baby of *A Chorus Line* and I worshipped everybody. I was in the presence of theater royalty, and I very much wanted to be a part of the group. They were very protective of me—this young, small-town, Southern girl—especially Thommie Walsh and Baayork Lee. They took me under their wings. They were the ones who would say to me, "Donna, you don't want to go to Studio 54. That's not for you." And they were right. To this day, I honor them for being so protective. They were older. They had been around. They could say, "Kid, don't do that."

For the show's finale, "One," we wore top hats that had been made just for us. And when each original cast member would leave the show, Alyce Gilbert, the wardrobe specialist, would give us our top hats. This hat represents more than the final number. It's about the whole experience.

—AS TOLD TO EMILY SPIVACK

Donna Drake is an actress, director, and choreographer, and was an original cast member of the Broadway show *A Chorus Line*. She moved to New York in 1974.

EILEEN
MYLES

We are all certain kinds of animals, and I'm a particular Irish–Eastern European mutt. The fawn color of this teeshirt, one of my favorite colors in the world, feels like that animal.

I've owned this teeshirt for seventeen years. I got it at the Banana Republic on Bleecker Street and Sixth Avenue. I may have been on my way to a date with this particular girlfriend I had at the time. She was twenty-nine and I was fifty. She introduced me to the word "hot." I'd never really used it in that way, but the word "hot" is somehow attached to this teeshirt and to her.

I first met this woman when I had a reading at a bar on the Lower East Side. I was going through a breakup, so I read a poem that was very sad. It had the refrain "My body has no friend." I thought if there was ever an ad for a girlfriend it was that moment. But apparently throughout the reading she was strategizing what she would say to capture me, so she hadn't even heard what I'd read.

When we began dating, this teeshirt became a feature. When you start dating someone, there's a stepping up in the buying of new clothes. You look at your clothes and they're looking old and sad and fucked up. You want to be this new person, so I think it was in this moment that I bought the teeshirt.

Where you lived and what you did dictated how you dressed—if you went to ACT UP, to P.S. 122, to the Poetry Project, if you lived in the East Village or Brooklyn— it was a very particular world in the late 1990s. For me, it was about being as butch as possible without body modification. Low-rise jeans, big belt, tight teeshirt, sneakers or boots, and probably a jean jacket.

Now this teeshirt is old and wrecked, so wearing it is a fine line between what's cute and hot and what's sad and old. I had a conversation about the shirt with Shaun at Seagull Salon, who cuts my hair. I took off my sweater and asked him if it was still OK to wear. He

said, "Girl, I've worn teeshirts so much worse than that. We wear bad teeshirts. That's who we are." It's a particular *we* I share with Shaun.

As I'm really feeling my chops at the moment, it's great to wear this shitty teeshirt. It becomes my own body because, intermittently, you really love it or hate it. An old thing is like that. You can determine how you feel today by whether you can wear it or not, like, Am I comfortable with myself and my history? Today this shirt is my shitty little apartment in the East Village, it's my old truck, it's a metonym.

Even though it's ragged, it's a piece of authenticating clothing, and I feel strangely hot. I wear it and I feel like the world is in place. I feel like the right animal at the right desk in the right house in the project that is my existence. The fact that I was just at the gym working out in this teeshirt makes me feel like I own this time. I look good and I am good and things are OK.

—*AS TOLD TO EMILY SPIVACK*

Eileen Myles is an author whose work includes *Afterglow* (a dog memoir), *Chelsea Girls*, and *I Must Be Living Twice: New and Selected Poems*. Originally from Boston, they have lived in New York since 1974.

ELIZABETH
MARIE RIVERA

The first ball I ever attended was the House of Latex Ball in 2000, put on by Gay Men's Health Crisis's House of Latex. I was awestruck watching the performances. Dazed. I also felt like, "I can do that. I want to do that." I introduced myself to Arbert Santana, the mother of the House of Latex, and said, "I'd like to be a part of the House." At the time, I was homeless, living in Covenant House, and I was doing sex work on the stroll in New York. The House of Latex became one of my safe havens.

A few years later, after acclimating to the House and becoming a staff member at GMHC, I attended the People of Color in Crisis Ball, which took place at The World in Times Square. I wore this corset to compete in the Junior Sex Siren category, which was for trans women who were in the beginning stages of their transition. Because I was working as a professional dominatrix at the time, the corset was an important piece of my attire. I wore it regularly. But before I went onstage, I had to remind myself: I can do this. I can get up on a runway in thigh-high vinyl boots, a two-piece PVC BDSM number, fishnet stockings, black satin gloves, a diamond-encrusted choker, and a corset, and own it. I had to exude sensuality, sexiness, and confidence. I had to sell myself to the audience and the judges.

When I got onstage, one of the judges immediately "chopped" me. To this day, I don't understand why. It might have been because the ballroom scene didn't look favorably upon the House of Latex, which was seen as a starter house. Perhaps that association automatically deemed me not good enough for the category. Or it could have been that I was fairly new to the scene. Regardless, it caused a scandal. The ball's host stepped in and insisted I have a fair opportunity.

Ultimately, I won the category. At that moment, I felt validated by my ballroom peers, not only as a woman but also as an attractive, sexy transgender woman.

One of the first people I connected with deeply in the ballroom community was

Willi Ninja, the godfather of voguing and mother at the House of Ninja, who had been featured in the documentary *Paris Is Burning*. I had watched it in high school while living at a foster home and loved it. Willi was warm and welcoming to me. I remember him pointing me out to his friends, saying, "I like her. There aren't too many girls like her in the scene." He told me, "One day you're going to be a Ninja." When Willi fell ill, because I was working at Gay Men's Health Crisis, the House of Ninja reached out to me for help so he could get connected to the health services he needed.

Eventually, the members of the House of Latex dispersed. I wanted to be invited to another house based on my own merit, so I stayed *007*, which means you are a free agent in the ballroom scene. One night my sister and I ran into Benny Ninja and Javier Ninja outside the LGBT Center. They asked me, "Where have you been? What house are you in now?" I hadn't been out on the scene as much. Willi had passed away at that point, and Benny said, "Didn't Willi say something about you being in the House of Ninja?" I answered shyly, "Maybe . . . ?" and he said, "OK, so you're a Ninja then. Hello!"

I had always thought I wasn't good enough for the House of Ninja, but clearly others thought differently, especially Willi. To this day, it surprises me that Willi Ninja even acknowledged me, let alone wanted me to join the house. I carry the Ninja name humbly and honorably.

I know I did a lot of work to get there. Back when I was staying at Covenant House, a resident advisor I'd had repeated conflicts with refused to call me by my preferred name, Elizabeth. In front of ten people, he said, "You came in with your given name on your ID card. Don't expect me to call you any other name." I said, "You will refer to me as Elizabeth. Mark my words." I went to the director at CH and complained. A couple of weeks later, I walked into the CH lobby and that same resident advisor was at the front desk. I was prepared for him to call me by the name on my birth certificate, but he said, "Good evening, Elizabeth." I stopped in my tracks and responded, "Oh my God, what? Can you please say that again?" After a pause, he reluctantly repeated himself. Then I said, "Thank you. And good evening to you, too." I hadn't asked for a lot, but I felt so accomplished. I had to advocate for myself, and in doing so I became an advocate for the trans community. People started recognizing this spunky little Puerto Rican trans girl who wouldn't take any bullshit from anyone.

—AS TOLD TO EMILY SPIVACK

Elizabeth Marie Rivera, from the House of Ninja, has been a member of the New York City house/ballroom community for two decades. A transgender community activist fighting for social justice, she currently works as an HIV counseling, testing, and referral specialist for the Latino Commission on AIDS. She moved to New York in 1998 and currently lives in Brooklyn.

ELIZABETH SWEETHEART

I hitchhiked down to New York from New Brunswick, Canada, in 1964. I was twenty-one and I'd just graduated from college. The only things I brought were the clothes I was wearing, my sketchbook, my pillow, and my ice skates.

I didn't know anybody when I arrived. I was temporarily staying at the Y, and I asked someone on the street where I could find a place to live. The person told me you couldn't get an apartment unless you had a job. I didn't know how to get a job, so I asked someone else on the street, "How do you get a job here?" and the person told me to go to the employment agency. The woman at the agency asked me, "What can you do?" I said, "Nothing really, but I have my sketchbook." She looked at it and said, "Oh my gosh, I'm going to send you on an interview right now." And I got the job.

That job was for a studio in the Garment Center, working as an artist designing fabric prints that were sold to a manufacturer. My first day, I went to work dressed as a beatnik and they said, "You can't come to work dressed like that." But I didn't have any other clothes. You weren't allowed to wear tights and a smock dress, so they bought me two blouses and two skirts, which I'd handwash every day.

I worked at the studio for a while and then took a break to do my own artwork. I later returned to my friend at the employment agency, who got me work again. This cycle continued until I started my own studio.

Once I began my studio, Sweetheart, I would wear overalls to work. I'd just put them on and go. It became my uniform and I would wear them everywhere—to work in my garden or to a Broadway show. If you look in my cupboard, it's all overalls. I'd wear black velvet overalls, purple overalls, blue overalls, always kid-size because I'm so small. Then, about twenty years ago, when I was in my fifties, I started wearing only green overalls. I'd buy white ones or bleach the overalls I had and dye them green. This pair I tie-dyed with bleach. I put hearts all over them—because I'm Sweetheart—and added a Canadian pin.

Wearing all green happened over time. My dad invited me to Florida for Christmas and I went into a store that sold green nail polish. I'd never seen it before. I bought some and mixed it with yellow, making my own green color. Then I put a green streak in my hair and made a green bracelet. I painted my glasses with that green nail polish.

Every person from every background loves the color green. I could be on Smith Street or Court Street in my neighborhood in Brooklyn and the kids, who sometimes are given school assignments to write songs and poems about the Green Lady, will recognize me, and their reactions will be amazing. I love all the young people. I'll give them a big hug and they'll be even happier. I got off the train recently behind this British guy who turned to me and said, "In London, we call you the happy green lady." I've always talked to everybody on the street in New York. It's never stopped since I arrived and asked someone how to get an apartment, but it's easier when you're wearing green. You hear stories of people being frightened and afraid here, but I find that no matter what, everybody has something good in them. That comes out especially because I'm in green.

—AS TOLD TO EMILY SPIVACK

Elizabeth Sweetheart, also known as the "Green Lady of Brooklyn," is an artist and textile designer. She moved to New York from Canada in 1964 and currently lives in Brooklyn.

EMILY
SPIVACK

I don't celebrate Easter. I'm Jewish, so usually the day marks the return of spring, pastels, and milk chocolate. In 2013, though, a friend invited me to an Easter supper at the home of Melissa Mathison, screenwriter of *E.T.* and *The Black Stallion*. I'd met Melissa at a party a couple of months before, and she'd been sincere and down-to-earth, but I was apprehensive. I imagined the gathering would be fancy, in a posh home full of well-heeled strangers taking part in traditions for a holiday I didn't celebrate. I felt out of place even before I arrived.

That Sunday morning, standing in front of my closet, I struggled with what to wear. Nothing felt right for the occasion. I settled on a high-waisted, dark-pink-and-burnt-orange plaid skirt purchased at a sample sale on Fourteenth Street a few years prior and a dark-pink, long-sleeve T-shirt. I wore a pair of tights from Sock Man on St. Marks that had a huge hole in the crotch from when I last wore them but that matched perfectly. I pulled on a slip because my mother taught me to always wear a slip. And bronze metallic flats.

I felt a chill on the subway as we rode from Brooklyn to Melissa's apartment just off Central Park and around the corner from the Plaza Hotel. It was probably a combination of nervous energy and a draft in my crotch where my tights had split. I berated myself. None of the other guests would dare wear something ripped.

We arrived early. A doorman motioned us in the direction of the festivities. Melissa greeted us warmly. Her apartment was luxe and meant for entertaining, appointed in an ornate eighteenth-century style. I felt surrounded by important things carefully chosen in ivory, taupe, and gold tones. I noticed the cut crystal table lamps, the brocade window treatments, the Chesterfield club chairs.

Guests had been asked to either bring a dish or make something there. We'd suggested biscuits, which seemed appropriate given the Southern gentility I associated with the word "supper." She handed us mixing bowls, a rolling pin, and the ingredients.

I could hear the din of guests arriving, but I remained in the kitchen. I immersed myself in mixing the ingredients and placing disks of dough onto a baking sheet, a task that likely didn't require the level of focus I clung to. The oven timer buzzed that the biscuits were done when Melissa walked in. "I don't bake much. I have no idea how these turned out," I confided to her. "They might be a disaster." She responded, "Why don't you give one to Joan to taste? She'll let you know what she thinks."

I put one biscuit on a plate with butter and jam and followed Melissa into the living room. The festivities were now fully under way. About twenty people were milling around, cocktails in hand. I followed Melissa's gaze to the suggested biscuit taste tester. I looked back at Melissa, surprised. She nodded encouragingly.

Joan Didion was sitting by herself in an overstuffed chair in the middle of the living room. I walked over. "Hi, Joan. I'm Emily. Melissa said you might like to try a biscuit from the batch I just made. I wasn't sure if you'd like butter or jam, so I've made you a plate with both."

Joan looked up at me. She appeared even more fragile and tiny and bird-like than in the photos I'd seen of her. Her hair was pulled back with two clips in her signature style. A cane leaned against her chair. The chair seemed to swallow her up. She looked a little surprised, but she took the plate.

Before I was overcome with anxiety about what to say to my favorite writer, my friend tapped me on the shoulder. He introduced me to one person and then another, a casting director, a screenwriter, an author, all with impressive résumés welcomingly disguised by the informal Sunday supper vibes.

I made idle chitchat for a few minutes but was distracted. Out of the corner of my eye, I could see Joan eating the biscuit I'd made. There was a pause in the conversation. I excused myself and turned to Joan. Her plate was empty. She asked, "Could I have another?" Restraining my giddiness, I returned moments later with one biscuit for Joan and one for myself.

This time, she acknowledged me with familiarity. I sat on a stool next to her, knees together, aware of my ripped tights. She pulled herself up from the deep chair and sat, slightly concave, with one arm on the armrest. She told me that she usually hosted her own gathering for Easter, but this year, because she had broken her ankle, she couldn't maintain her annual tradition. She'd accepted Melissa's invitation instead.

Perhaps I should have expressed how much I admired her writing or asked about her work. Perhaps I should have told her about mine. I'm sure it was a fleeting, inconsequential moment for her. Regardless, sitting quietly with Joan Didion, eating biscuits I'd made off the plates on our laps, I was at ease.

Emily Spivack is an artist, writer, editor, and the author of *Worn Stories* and *Worn in New York*. She has lived in New York since 2001.

ERNIE
GLAM

I wore this outfit I'd made on *The Joan Rivers Show*. Michael Alig, Leigh Bowery, James St. James, Amanda Lepore, and I had been invited as guests for an episode about club kids. We stayed up all night, of course, and I think we were all high on drugs during the taping. I know I was. We wouldn't have gotten home from the club until five or six in the morning and then we had to be at the CBS Studio Center on Fifty-Seventh Street at 7 A.M.

I began working at Limelight in August 1990, and the producers for *Joan Rivers* came six months or a year after we had started the Disco 2000 party, because it took some time to build up its reputation. As the party became more outlandish and people started talking about it, TV producers showed up. On the night they came, I was wearing this costume I'd designed, but with a cage sewn into the collar that went around my head. They were like, "You have to come on the show and wear that exact costume!" So I did.

We had created this pop-culture hoax that there was something called "club kids" who were making thousands of dollars just being decadent and wild—which certainly wasn't true but was one of the reasons Joan wanted us on the show. We would stick to that script and people would be outraged. The more outrage, the more the media would want to cover our outlandish behavior. We intentionally devised this hoax, which then became real, and now club kids are a stereotype.

We weren't nervous to be on *The Joan Rivers Show*, because we were all a bunch of attention whores, so it's not like the cameras made us nervous. The only person who had stage fright was Amanda Lepore—this was before she became an international diva. We were trying to calm her down and Michael said, "You know what? You don't have to say anything. Or, just say, 'I want to be every man's fantasy. I'm so beautiful and blonde,' no matter what the question," which is what she wound up doing. Mostly, we were nervous that Joan Rivers was going to be mean to us. But she was really nice and we were on for the entire show. Afterward, we took pictures with her backstage.

I learned to sew at FIT because most of the crazy things Michael Alig and I wanted to wear couldn't be found in stores. I would design our outfits from dead-stock children's fabric I bought on Thirty-Ninth Street between Seventh and Eighth Avenues. In the Garment Center at that time, you could find fun, innocent prints and I would make them vulgar, like a jumpsuit with no back so Michael's ass would hang out. It was this combination of sweetness and obscenity we were going for.

You have to put in context what was going on when the club kids thing started. It was the late 1980s and the AIDS epidemic was raging. If you were gay, you could die from having sex. All these young gay people who were just becoming sexual were faced with this horrible disease. Club kids internalized that fear of sex and of sex equaling death. They responded to it by making themselves grotesque so they wouldn't necessarily be sexually appealing. But at the same time, you were wearing a very erotic outfit, like maybe your butt would be showing or you'd be wearing bondage gear.

It was also a very conservative time in the United States. Reagan was president and we'd had an economic meltdown in 1987. Big nightclubs closed and the lavishness of New York pretty much ended. That allowed club kids to do low-budget, DIY parties, like, "Let's have an outlaw party in the park and just buy a case of vodka and it will only cost $150." It was a total shift in mindset.

From 1985 until 1990, I lived on South Third Street and Rodney in Williamsburg when it was still all Dominican and Puerto Rican. I was going out all dressed up, and I would carry a mini baseball bat or stick for protection walking to and from the Lorimer Street station. I wasn't scared of living there, because it was a Hispanic neighborhood and I grew up in a Hispanic neighborhood. But people would see what I looked like and try to start shit with me. I knew I had to have something to dissuade them. When I got to the nightclub, I would hide the stick or baseball bat in a nearby garbage can. At the end of the night, I'd pick up what I'd hidden and go home.

Growing up in Sacramento, I lived in a Mexican bubble with my immigrant parents, who were very strict. I was also around a lot of anti-Mexican sentiment. And I don't look like a typical Mexican person because I am much lighter than most, so I didn't fit in in my neighborhood. People who were not Mexicans didn't like Mexicans, and Mexicans didn't like me because they thought I was a white guy. And I was gay on top of it. There wasn't anything flamboyant in that bubble except mariachi.

As soon as I left my parents' house and got to the University of Pennsylvania, in 1980, I started dressing up in crazy clothes. I internalized that alienation and turned into this big freak. I had to justify not being accepted by putting on all this makeup and dressing

crazily. By doing this, it was understandable that people would reject me. Because just being your normal self and not being accepted is very painful.

—*AS TOLD TO EMILY SPIVACK*

Ernie Glam, a former club kid who played a central role in the New York City club scene of the late 1980s and early 1990s, currently works as a journalist and still takes part in the city's nightlife. He has lived in New York since 1984 and resides in the Bronx.

FAB 5
FREDDY

I'd been a hat guy since I was about eighteen years old. I think I was influenced by stylish men in old black-and-white films and images of jazz cats, when men wearing hats was a standard thing. I never did *Yo! MTV Raps* without a hat. That was a significant part of my look.

A couple years into hosting *MTV Raps*, around 1990 or 1991, I took my first trip to Jamaica to cover the Reggae Sunsplash music festival. During some downtime, I went to a craft market in Montego Bay and bought a hat with a particular straw weave. I've got a large head and it fit me well. It became a summer favorite of mine. I often rocked it with linen shorts sets Dapper Dan made for me. I rocked it well and knew I looked good.

I was seeing a girl back then and we eventually broke up. The problem was I'd left my straw hat from that Montego Bay craft fair at her house. She gave me some kind of arcane story of where it was or how she'd lost it and soon after our communication broke down. I was like, "Whatever. I need to get a new straw hat."

To track down another, I had shown a picture of myself in the hat to this African American gentleman at a hat store on Fifth Avenue called JJ Hat Center. He told me that the hat's weave used to be more common back in the day when hats weren't mass-produced in China as many are now. Knowing that gave my former straw hat even more cachet. I wanted another, but I knew I wasn't going back to Jamaica anytime soon. I had friends going to Montego Bay and I asked them to stop at the same craft market to pick one up for me. Since they'd seen me wearing the hat on the show, they knew what I was talking about. Bottom line, the hat they brought back for me was not it. It was just wrong. Months later, I had another friend going to Mo Bay and I asked him to pick one up for me. Would you believe he came back with the same straw hat as my other friends?

The thing that made replacing that hat so imperative was that I was on TV every week. I knew this little show was being watched in millions of homes across America and around the world. It was surreal, because at that time in New York, not everywhere

was wired for cable. And still, I was becoming a household name, but only in homes with cable. None of my friends had cable. I didn't have cable, so during the first couple of years, I couldn't watch the show when it aired. They'd messenger me a couple of VHS copies every week and they'd send one to my family in Bed-Stuy because they didn't have cable either. I'd do the show but still be in my largely cable-free Lower East Side downtown zone, still making art. I took pride in connecting the dots between being a downtown New York bohemian artist and a part of the growing hip-hop culture. Regardless, being on TV that frequently meant I needed to change my on-camera wardrobe weekly. I had to keep my look right, and my hat was an important part of that, kinda like a crown.

American black folks in particular look at what you wear in a certain kind of way, so it was important for me to be stylish but have my own individual Fab style. I came up as a shorty in Bed-Stuy during the time when you could be 100 percent street, but still clean up and put on silk or gabardine slacks, nice casual dress shoes like Playboys, Clarks, or British Walkers, Italian knits, suedes and leathers, and nice hats. I didn't have real money so a youngin' like me would put the pricier items on layaway for months, but I always knew what the big kids and fly cats were wearing.

A couple years ago, I heard through social media from the woman I'd been dating back then. She's got a family now and lives in New Jersey. Everything's all good—we got on the phone to catch up. In the course of the conversation, she was like, "I've got something for you. I think you're going to be surprised." A few weeks later, a box arrived in the mail. I opened it and just sat there, like, wow. It was the straw hat. Finally, I got it back.

—AS TOLD TO EMILY SPIVACK

Fab 5 Freddy is an artist who hosted *Yo! MTV Raps* from 1988 to 1995. He is a native New Yorker who was born in Brooklyn and currently lives in Harlem.

FRANCES
GOLDIN

I have been going to the Gay Pride parade since the beginning. I always go to the same place—Eighteenth Street and Broadway, the northeast corner. These days my home attendant goes early to save a place for me and brings my wheelchair. I can yell and carry my sign, and when I get tired, I sit down in the chair.

It's hot and exhausting, so I always wear a hat to deflect the sun. It's purple, of course, and usually it's this cowboy hat. I started wearing purple fifteen years ago when I was seventy-seven. I just loved the color. It's very passionate. Along with my hat, I bring the same sign to the parade every year. I came up with the slogan; it says, "I Love My Lesbian Daughters." A man I met later in life and who became my lover painted it.

I've seen how the Gay Pride parade has changed during my lifetime. Especially with the police. They are told to be very gentle and they are. When I want to cross the street— and you're not allowed during the parade—they get me across. There is a lot of love. There's even a police contingent in the parade now. What a change! We cheer them on.

A few years ago, I had a heart attack and I couldn't go to the parade. I was really laid up. The next year I returned. I brought my sign and wore my purple hat. What astonished me was the number of people who recognized me, my purple hat, and my sign. They came over and told me they had missed me. I wanted to weep I was so happy.

Sometimes my daughters come with me to the parade—one lives in upstate New York and the other lives in California. But whoever joins me becomes my daughter. I have a very dear black friend who has joined me, and people ask, "Is she your daughter?" I say, "Yes, she's my daughter."

I'm ninety-two and still kicking ass. Why do you think I've lived this long? Marching and demonstrating, not sitting home and knitting.

—AS TOLD TO EMILY SPIVACK

Frances Goldin is a social justice activist and literary agent. Born in Queens, she has lived in Manhattan for more than seventy years.

GAIL
OLDFIELD

My mother was a dance teacher on Staten Island, which is how I began dancing. I guess she saw that I had talent and started bringing me into the city twice a week for dance classes when I was three years old. I studied with a teacher whose studio was above the Ed Sullivan Theater marquee on Fifty-Third Street. At the time, it took two hours to get from where I lived, at the very end of Staten Island, to my classes. We would take a bus or train to the ferry and the subway uptown. My mother took me to my classes until I was eleven years old and then she let me go by myself.

When I finished high school, I planned to work on Wall Street for one of the banks. That was in 1959. I was going to be a working girl, doing typing and stenography, and teaching dance back home on Staten Island. I never planned on having a professional dance career. But then I heard about auditions for the Rockettes. I sent them a letter and they responded with a telegram telling me to come to the audition. I had two weeks to prepare.

I went to the tryouts with my mother. I remember it like it was yesterday. Fifty girls were waiting to audition. You had to do a tap routine, a jazz routine, a ballet combination, turns, and kicks—front kicks, side kicks, over-your-head kicks. You brought sheet music and a piano player accompanied you. Russell Markert, the originator of the Rockettes, was strict and honest with the girls. During the audition, he'd say, "Your dance teacher is taking your money. Find a new one." Or, "Spruce up!" Only four girls made it during those tryouts and I was one of them.

For four years, until 1963, I worked four or five weeks straight with one week off. During the Christmas season, we would do five shows a day. At the beginning I was living on Staten Island. Our last show ended by ten and I would get home around midnight. I would turn around in the morning and head back into the city. The pay wasn't fabulous, but you could live off it. Eventually, I moved into an apartment with four other girls a couple blocks from the theater on Fifty-Seventh or Fifty-Ninth Street.

This shoe is from my first Christmas show. I wore it during the "Parade of the Wooden Soldiers," which they're still doing today. We wore pants made of heavily starched sailcloth, so we couldn't bend our legs. We had to stand on a chair just to get into them. We also wore these tap shoes with a clunky heel, because at the end of the routine we would do "The Fall." It would start with Santa Claus shooting a cannon and then the soldiers would fall back very slowly, like dominos. You would catch the girl in front of you in the crook of your arm and trust that the girl behind you would do the same as you fell back. That's why we had such heavy shoes with braces on the heels. That Christmas, Russell Markert, who called us his dancing daughters, gave each of us a gold charm in the form of a wooden soldier, which looked just like our costumes.

We weren't allowed to keep any of our costumes or shoes. They all belonged to Radio City. The shoe department was cleaned out in the mid-1970s, and a friend and former Rockette who was helping found just one tap shoe with my maiden name, Paduani, written on the bottom. To my shock, it arrived in the mail one day, this one shoe from the wooden soldier routine.

—AS TOLD TO EMILY SPIVACK

Gail Oldfield is a dancer, instructor, and choreographer who was in the Rockettes from 1959 to 1963. She is originally from Staten Island and currently lives in Pennsylvania.

GAY
TALESE

I have an affinity for familiarity. What I have now, in many cases, is what I decided I wanted fifty years ago. My wife, Nan, and I married in 1959, and that same year, she moved into my rent-controlled apartment in a brownstone on East Sixty-First Street. Later, I bought the brownstone, and I still live there today. Where I sleep, our marital bedroom, has been the same since we moved in. In 1958, I bought a Triumph TR3, an English sports car. I still drive it. If I make a decision, I don't change it. Not because I have a certitude about things. But once I do it, it's done.

And then there are my clothes. I have sixty to seventy winter suits and probably the same number of summer suits. I still wear a Brioni suit I bought in Rome in 1959 on the occasion of my marriage. I have a whole room just for hats and ties. I have about fifty hats, mostly wintertime fedoras, and about three hundred ties that range from 1950s styles to where we are now. Styles change, colors change, fabrics change, the width of a tie changes—I don't care. I can still live in any decade I want.

Some of my clothes require facelifts as I get older. I'm very slender, but because I might have put on four or five pounds in fifty years, certain jackets and suits become a little tight. Instead of getting rid of clothes, I'll have new fabric artistically inserted into the seams of a jacket to give it a whole new look. I have fifteen to twenty jackets I've completely redesigned with the main purpose of not getting rid of them. I'll take them across the street to the tailor and say, "The cuffs and lapel are getting worn. Let's add tan piping across this brown jacket." Or, "The back is a little tight, so we're putting two stripes, maybe suede inserts, that fit in an artistic way." It's the same with shoes. I never get rid of them. I have them redesigned or remade by a shoemaker on Lexington Avenue and Seventieth Street, Vincent & Edgar.

I never go more than a five-minute walk from where I live to buy whatever I need—a haircut, a bottle of Scotch, or some milk. I have tremendous loyalty to restaurants. I know

the names of waiters and follow them when restaurants close. Waiters who I once ordered martinis and dinners from at Elaine's in 1962, if they're still alive and I'm still alive in 2017, I order my martinis from them at Caravaggio, on Madison and Seventy-Fourth Street. Recently, Nan and I went to dinner at Primola, on Second Avenue and Sixty-Fourth Street, with my friend Don DeLillo, a well-known novelist, and his wife. I've known the man who owns the restaurant for fifty years, since he was a waiter at another restaurant. And even though I'm older, not so much do I feel older, because I'm wearing a suit to dinner that I wore for the first time in 1962, when I was a young reporter at the *New York Times*.

I'm a working writer, eighty-four, and my wife is a working editor, eighty-two. Our life together hasn't changed. Why? Because I don't want it to change. Because I like the way we did it originally and I like that I made the right decisions, even if nobody knows it or agrees with me. I have had to make certain concessions. But never did I sell out the suits, never did I sell out the car, never did I sell out the wife, never did I sell out the brownstone. When we first bought the building, we fixed it up like I fix up jackets, like this one, with only slight alterations from when I first bought them. It's a locked-in love affair, a lifetime love affair with people, objects, and locations, and a memory that goes back for more than half a century with familiarity, satisfaction, and enduring commitment.

It's central, too, to my writing. Many of my pieces are fifty years old and they still hold up. I never wanted to write for the next day's newspaper. I wanted to write for the newspaper that was going to be read years later. I never wanted to be on the front page, because the front page is what matters today. Why couldn't I do what John O'Hara, Irwin Shaw, F. Scott Fitzgerald, or Ernest Hemingway did with fiction? Why can't I, as a journalist, write permanently interesting stories of lasting value and endless readability that you could read in 1959 or 2017? I believe I'm a foot soldier that historians, long after I'm dead, will appreciate for the insight I imparted into the story. This is very glorious thinking, but I'm not ashamed of it.

Dressing, to me, is a celebration of being alive. It's also an appreciation for what I do, which is talk to people and write about people. I dress the same way to interview a homeless person as I do to interview a guy in a hard hat building a bridge, a gangster, or Mike Bloomberg. I dress for the story.

And even if I don't have to dress up for anybody but myself, I still dress up. On a day when I'm around the house, I'll wear an ascot. I'll also wear loafers, but I would never wear them in the street. I like to have finer shoes when I'm walking in public. I take walks in the afternoons and I've always dressed up. Whether it's on Madison Avenue or Canal Street makes no damn difference. I'm always dressed in a way that I make a fine appearance, that I uphold standards.

I live on a block with many doctors and I see old people coming in for their appointments. The old people look like hell. They're sagging, their death is about two weeks away. And I think, "Jesus, what the hell is the matter with you? If you burn your windbreaker and put on a Brioni suit, a better pair of shoes, and a fedora instead of that crooked baseball cap, you'll look better and you'll feel better." I tell these people, but they don't listen to me.

Well, that's not true for Gay Talese. Eighty-four years old and I walk outside looking like a million bucks.

—AS TOLD TO EMILY SPIVACK

Gay Talese is a bestselling author and journalist whose work includes "Frank Sinatra Has a Cold" and "The Voyeur's Motel." He has lived in New York since 1953.

GENESIS BREYER P-ORRIDGE

In 1993, we were in the middle of a not-very-amicable divorce with two children. We'd only just come to America, to California, the year before, after not being allowed back in Britain. It was an intense time, and when we wanted to relax, we would come to New York for a long weekend and stay with a good friend, the writer Terence Sellers. She had a professional dungeon on West Twenty-Third Street. We would stay there and basically take high-grade pharmaceutical ecstasy and then party for three days just to blow off all the stress, which mainly meant going to the club Jackie 60 run by Chi Chi Valenti and Johnny Dynell. It was one of those clubs that really welcomed all the freaks of the East Village and the Meatpacking District when those neighborhoods were still naughty and depraved, and the center of S&M clubs.

That particular weekend, we had been awake for three days and finally were ready to sleep. We came back to the dungeon at who knows what time and decided to sleep in there, so as not to wake up Terence in her apartment. We lay on the floor wrapped in a sheet among all these torture devices and passed out.

In the morning, we woke up to the sound of voices, and, for a minute, we couldn't remember where we were. The door was open, so there was a rectangle of light. As our eyes started to adjust, we saw this very tall, slim girl with a perfect 1960s Brian Jones bob wearing 1960s-style jeans with go-go boots and an Andy Warhol striped sweater. Completely automatically, without any real thought, we blurted out loud, "Dear Universe, if we can be with that person for the rest of our life, that's all we want." We had no idea who it was. As we were saying that, the person, who we later learned was Lady Jaye, began to elegantly smoke a cigarette while gradually getting undressed and then re-dressed until she was in all fetish leather and rubber. It turned out that another dominatrix, out of our view, had told her/him not to go into the dungeon and that we were "bad news" and "really weird," which Lady Jaye took as an invitation.

S/he asked us if we wanted to go out somewhere with her/him that night, adding that we couldn't go out dressed in what we were wearing since we were in awful rave gear. Lady Jaye took us to her/his apartment on East Eleventh Street and dressed us up. Her/his clothes and her/his shoes fit us perfectly. S/he put us in a bottle-green velvet body suit, a leather skirt, and Fluevog shoes, which s/he called Goat Shoes because they looked like goats' feet. Then s/he took us to a Tibetan shop and bought lots of little bones and beads and wove them into the dreadlocks we had then. Finally Lady Jaye declared, "Now you're ready to go out with me!"

We went back to Terence's and s/he came back later to pick us up. S/he turned up in a car service with a bottle of champagne, wearing five-inch heels and skintight black leather from head to foot. S/he took us to a place called Saddles in the Meatpacking District, an S&M club. At one point we noticed Lady Jaye was moving in a strange way and we looked down. S/he was brutally digging her heel into a naked man's hand who was prostrated at her feet. He must have been there about ten minutes. We just thought that was so cool, to be doing that without referencing it in any way.

From then on, we were together. The perfect 1960s look was what first did it for us. Anyone who looks like Brian Jones mixed with Edie Sedgwick is special in our book. When s/he saw us, s/he knew this connection was different. S/he'd had lots of boyfriends and girlfriends and had a decadent New York life, but that was it. S/he wasn't interested in anyone else, just our absolute, unconditional love.

We didn't want to rush anything. We decided to act like we were both virgins. We were going to get to know each other very slowly and savor every nuance of falling in love. Once, we came back to visit New York when we were totally obsessed with each other but hadn't quite admitted it yet. S/he had gotten two matching pairs of black silk pajamas so we could be physically discreet, because we were sleeping in the same bed. We waited a whole year before we actually made love and had full sex. We were together 24-7 until s/he dropped her body in October 2007. We still are together, s/he residing in an immaterial realm and myself still here in a material one.

We wore this striped top all the time. Eventually we had to get new ones because we wore them out. This is the second one. As our love grew deeper and more obsessively total, we decided we wanted to become each other, to be absorbed into each other, to become one being. That's when we started to buy two of everything—matching outfits, matching makeup, matching hair, matching everything to reflect our desire to be as close as possible. This shirt and the 1960s look were day clothes, and evenings were often fetish. We loved dressing in sensual lingerie to do housework, too.

We didn't want there to be any separation. If we could, we would have just held each other in an embrace and melted into each other to literally become one. We still will when we drop this body; that's the plan. We can join our two consciences. *Big* love, we call it. It's a truly unconditional love, absolute total surrender to the other, without any fear or hesitation or possibility of regret. By becoming each other's half, we were more. We became complete. Each other's "other half." Neither male nor female but a unity of both. A divine hermaphrodite. We chose to call this perfect union the *pandrogyne*.

—*AS TOLD TO EMILY SPIVACK*

Genesis Breyer P-Orridge is an artist, writer, musician, and a founding member of Throbbing Gristle and Psychic TV. They identify as third being, beyond gender, and began using the pronoun "we" after meeting partner Lady Jaye. Together, they created the Pandrogyne Project. They moved to Queens in 1993 and P-Orridge has lived in Manhattan since 2009.

GEORGE
HIRSCH

Nineteen seventy-six was just terrible in New York City. We all knew the city was on the edge of bankruptcy. Crime was high. In many parts of the city, people didn't feel safe. Johnny Carson used to make jokes about avoiding Central Park that everyone immediately understood because no sane person would venture there in the evening.

It was a very tough time. I would say that was the sole reason we were able to convince Mayor Beame to let us go ahead with the five-borough marathon. When Manhattan Borough President Percy Sutton, New York Road Runners President Fred Lebow, and I met with the mayor, we showed him the proposed route and explained that a marathon throughout all five boroughs would add more festivity and revelry to the city and its upcoming bicentennial celebration. It was an unusual request, because, back then, there was only the Boston Marathon and the Yonkers Marathon. It wasn't like it is now, with a marathon in every self-respecting city.

We were already in a running boom. It started in 1972, when Frank Shorter, a very attractive, intelligent, articulate guy, won the marathon at the Munich Olympics. His win was a bright spot in what had been a very difficult Olympics. He wound up on the cover of *Life* magazine, and from then on, running became more mainstream.

Frank Shorter stayed at my brownstone on East Thirty-Second Street the night before the first five-borough New York City Marathon. Friends of mine who were running the race called to ask, "What is Frank eating? What is he doing?" There was a lot of anticipation, a lot of excitement among runners. I didn't have the heart to say that we'd just had a normal pasta dinner and then he'd had two vodkas. That wasn't what I would have expected.

The morning of the marathon, October 23, 1976, I put on the race T-shirt and headed to the starting line. It was standard to get a shirt with your entry fee—in this case, five dollars. Getting a T-shirt was a real attraction for runners in those days. Because it was such an amateur sport at the time, anything that we could get for free was a big deal.

We started out on the Verrazano Bridge, where the race still begins to this day. There were around 2,000 runners. Today there are 50,000 runners in the marathon, so it has to be very organized. But back then, we were all jogging around in front of the starting line, saying hello and chatting with each other. You could hear the sound of helicopters overhead and see boats underneath spraying water. When the gun went off and we started running, I looked toward Manhattan and thought, "This is really incredible."

The original course hasn't changed much over the years, except for the part in the Bronx. For that first race, the course crossed the Willis Avenue Bridge and went a few yards before turning back. That way, we could call it the five-borough marathon. Runners literally just ran around a lamppost in the Bronx, 180 degrees. We all grabbed the lamppost and swung ourselves around it. Now, there's a much bigger stretch in the borough.

The runners in that first race were hardcore. We weren't running to lose weight or meet the opposite sex. We were trying to run as fast as we could. To do that, we all believed that when it came to what we wore to run, less was better. The idea was to remove any milligram of weight you could. In fact, Frank Shorter trimmed everything off his race bib except for the number itself. We would run without socks because who wants to lug socks around for twenty-six miles? We'd wear Tigers, these Japanese-made shoes that today are called Asics. The soles were so thin you could step on a dime and tell if it was heads or tails.

Right from the beginning, the marathon became the best day in the life of the city. There was no looking back. I don't remember anyone ever asking, "Should we do that again?" It was the New York City Marathon. It was established.

—AS TOLD TO EMILY SPIVACK

George Hirsch, chairman of the board of the New York Road Runners, is a founder of the New York City Marathon. He is the founding publisher of *New York* magazine and was the longtime, worldwide publisher of *Runner's World*. He is a native New Yorker and currently lives in Harlem.

GERARD
MEADE

The year was 1964, I was ten, and the Beatles were about to conquer America. On February 9th, I watched with my folks in the living room of our small Woodside home as they took the stage for their first appearance on *The Ed Sullivan Show*. Even on our old black-and-white TV it was obvious—these guys were cool.

It was more than just their sound, barely audible above the screaming; it was the entire package. Music was a big part of my family. Dad played guitar a bit. One brother did also. Another brother favored more exotic instruments. I was a drummer, or rather a wannabe, playing a plastic snare and cymbal ensemble that Mom and I got with saving stamps from the Bohack's on Sixty-Ninth Street. I longed for a full drum kit. After *The Ed Sullivan Show* I added another item to my wish list—Beatle boots. Nothing could possibly be cooler: With a pair of those pointy-toed suckers, I could be the next Ringo. And that big heel wouldn't hurt either—I was vertically challenged.

I pestered my parents for a gift that was way outside their means. It made no sense with me still growing. I'd outgrow the shoes in no time and the cost would equal my clothing budget for the year. Mom came through the following Christmas, in a way. The boots she got me were cheap vinyl, pointed at the toe, but only ankle height with a much shorter heel. The interior was lined with some red furry stuff. They were kind of effeminate, possibly found in the bargain basement of a women's department store. They fit, though, and it was the best I was going to do.

I remember wearing the Beatle-esque boots while playing the drums and lip-synching to a record player at the St. Mary's talent show along with three other amateurs who probably still hold it against me. I think it was "She Loves You." I don't recall, but I doubt the nuns or priests appreciated the musical choice and I guarantee they could have done without the performance.

The Beatles returned the following year and played to an audience of 55,000 people at Shea Stadium in my home borough. No one had seen anything like it. Throughout that tour and long after, despite some skeptical looks and the occasional snide remark, I wore those boots. Eventually their inferior craftsmanship failed me.

Fourteen years later, I was selling stereo equipment for Tech Hifi on West Eighth Street in the Village. I still lived in Queens and took the subway to West Fourth Street, walking the couple of blocks from there to the store. Along the way I'd glance into the windows of the trendy shops. One store in particular on Eighth sold clothing favored by performers and artists, styles that were definitely outside the realm of traditional fashion. I was in a band at the time, The Extras. We played covers and originals, working mostly in small local clubs. We all had day jobs but managed to play out one or two nights a week while looking and hoping for more. Passing the shop one day, I noticed a pair of black boots in the window with a sharply pointed toe and Cuban heel. I had to investigate further. They were Beatle boots, but with a more contemporary Velcro strap.

In no position to spend money on special clothes to play gigs—we didn't make enough to warrant it—I shrugged it off but continued to think about them. Later that day, I returned to the store to ask about layaway plans. Mentioning that I worked down the block and played in an up-and-coming band had the desired effect. I finagled a slight discount and payment plan. About two months later the new footgear made its first appearance at a gig in Bayside. Before that year was out, they were on my feet as I stepped onto a far more significant stage: The Extras were headliners at CBGB. No longer striving to be Ringo, I now played keyboards and proudly wore my Beatle boots.

Buried behind keyboards and gear, nobody really noticed those boots. But to me they still looked, and felt, cool. The Extras had come a long way from the tiny suburban bars but sadly disbanded not long after that gig. The boots didn't make the cut in the spandex and big-hair days that followed. But out on the street? They were still sharp.

Gerard Meade is a semi-retired chef/carpenter/musician-turned-writer. He is a native New Yorker who was born and raised in Queens and currently lives on Long Island.

JANETTE
BECKMAN

I was working as a photographer for the music magazine *Melody Maker* when, in 1982, I heard about this thing called "hip-hop." The first ever hip-hop tour was coming to London, and I put my hand up to photograph a story about these musicians. I went to the hotel where they were staying, just me and my camera, and I photographed the double-dutch dancers, b-boys, and graffiti artists. I was blown away by the styling, attitude, and poses. People in London didn't look like that. Later that night, I went to the concert with GrandMixer D.ST, Fab 5 Freddy, Futura, and Afrika Bambaataa. DJs, break-dancers, rappers, and artists all onstage together, crazy and colorful, especially coming after punk, which, by that time, had gotten a little dreary.

That same year, after the story ran in *Melody Maker*, I went to visit a friend in New York over Christmas. The hip-hop stuff I'd just seen in London was happening all around the city, kids with boom boxes on their shoulders or break-dancing outside subway entrances. In New York, it's cold, but the sun's shining and people are selling hoop earrings and knock-off Gucci bags on the street. It was so exotic coming from London, where it rains all the time. After that, I never left.

I hadn't been in New York too long when another British magazine I'd been working for, *The Face*, called. "There's this group, Run-D.M.C. . . . you've never heard of them, but let's find out about them." So they gave me a phone number. It turned out to be Jam Master Jay's mom. Jay told me to meet him by the Hollis train station. I went up there with my Hasselblad camera and photographed Run-D.M.C. hanging out with their friends on their street.

I started getting jobs with Def Jam. They had this really scruffy office not too far from my apartment. I remember walking in to show them my photos. Lyor Cohen was sitting at his desk with a cigar in his mouth and his feet up on the desk, shouting into the phone,

something like, "$100,000! Run-D.M.C.!" I asked him to look at my portfolio. He told me, "Ah, yeah yeah yeah, OK. Do press pictures for LL Cool J."

Because I was British and a woman, everybody was super nice to me. They were curious about what I was doing in New York and why I was interested in them. When I'd photograph Salt-N-Pepa or Leaders of the New School, they'd ask me questions, I'd ask them questions, and we'd collaborate. In retrospect, it was a huge deal to be allowed into that world, to, say, photograph Afrika Bambaataa in the Bronx. I think it really helped to be a white woman from another country. If I'd been a white American guy, I wouldn't have been able to get the pictures I got. I was like a stranger in a strange land.

At the time, I was living on Franklin Street in Tribeca, and there was nothing down there. At night, it was dark. Like the song "The Message," it really was "junkies in the alley with a baseball bat." It was dangerous, but I didn't think about the danger. I'd been living in a virtual squat in London that didn't have heating, so when I moved to New York, and the place had steam heat, I was really happy.

One day, probably in 1988 after I'd been working with Def Jam for a little while, I came into the office and either Lyor Cohen or Bill Adler, Def Jam's publicist, had something for me. They'd decided I was worthy of having this Def Jam jacket. They'd even gotten my name embroidered onto it. To be given a Def Jam jacket was the ultimate in cool. Wearing it made me feel like I was part of the posse. It was a badge of honor—better than being knighted by the queen—and I wore it on all my photo shoots.

To this day, the jacket remains my garment of choice the moment it gets chilly. When I wear it, people come up to me on the subway and ask about it. They know it's old and they look at me like I'm an OG. One time a limo halted next to me on the sidewalk. Someone yelled out the window, "Yo, Def Jam, where'd you get that jacket? Can I buy it?" But whenever that happens, I tell them it has my name embroidered on it and I won't sell it. Because the jacket is about coming to New York to live that New York life.

—AS TOLD TO EMILY SPIVACK

Janette Beckman is a British photographer whose work has focused on documenting hip-hop and rebel cultures. She has been living and working in New York since 1983.

JD
SAMSON

My ex-lover from when I was a lot younger, the artist Emily Roysdon, made this shirt for me. The photo on the shirt is of Emily dressed up like Elton John for Halloween. She sewed a tag inside that says "JDE 12501," our initials and the date, January 25, 2001, although I can't remember what that date means.

This shirt reminds me of that time in New York with Emily right out of college. It represents this vulnerable sweetness of just being young and queer and radical. Emily and I got wasted, ran around, and acted wild. We'd go to the Hole, the Cock, Meow Mix, Julius, and Crazy Nanny's, which was this lesbian bar in the West Village. We'd hang out at St. Mark's Bookshop. We'd eat at Veselka and B&H Dairy. Every weekend, we went to Dumba, a queer, all-ages, bring-your-own-alcohol, cultural squat in DUMBO on Jay Street. They had punk shows, film festivals, and sex parties. It's where I met so many of the people who are still in my life today.

Things felt easy, but it was also a time when Rudy Giuliani was mayor and you weren't allowed to dance at bars. We had this group called Dykes Can Dance and we would dance where you weren't supposed to. My favorite parts of the shirt are the sweaty armpits. I wore it and danced so hard.

During our time together, Emily and I were trying to find out what our careers were going to be and what kind of art we were going to make. We used each other as a canvas. It was a very exploratory relationship for us—both sexually and creatively. We didn't have to be afraid of our audience because we didn't have an audience. We didn't second-guess ourselves.

We were together for three years. Now we're best friends and I have a tattoo of Emily on my arm. We both have our own careers and lives, but we always find in each other that space to be safe, to understand one another. This shirt reminds me that we speak the same language.

—*AS TOLD TO EMILY SPIVACK*

JD Samson is a musician best known for her role in Le Tigre and the DJ collective MEN. She has lived in New York since 2000.

JENJI
KOHAN

I was going to Columbia University and living in a welfare hotel on 110th Street. I got free toilet paper from the government, covered everything in contact paper, and called it home. I also had a horrible roach problem, but a *santero* on Amsterdam gave me something to burn on my hot plate, which helped. After that I'd go to him before exams and he'd give me candles with sacred oils and glitter to burn, and that was also very helpful.

One night I went downtown with a friend to a club called SOB's. A group of Japanese businessmen were also there, and their weaselly little lawyer came up to us and said, "Hey, ladies, I've got my clients over here, and it would really make their night if you danced with them." I was grossed out, but my friend spoke Japanese and wanted to practice with them so we agreed.

She, of course, danced with the young, cute one. I got the heavyset fellow in his mid-fifties named Kuniaki Tanaka. At the end of the night, I thought, "OK, this was an adventure," and we went back uptown, not with the guys. My friend told me, "By the way, I gave them your phone number. They want to take us out to dinner tomorrow." I was not that into the idea, but my mother always said, "If they feed you, go." So I went.

A town car came to my welfare hotel to pick us up. A bunch of us ended up at some big restaurant in the Fifties—a Japanese pop star and his girlfriend, my old guy, his younger partner who my friend liked, and his bodyguard. I didn't really know what was going on, but the food was really good. I refused to drink, because I wanted my faculties. It was a big mistake on my part because after that night, whenever they'd buy a $1,000 bottle of champagne, they'd get me a Perrier.

Once Tanaka bought me a Chanel purse, which I felt super weird about, but the salesgirl pulled me aside and said, "Honey, he wants to buy it for you. Take it." I always thought, "Well, one day when I'm old, I'll give the purse to my daughter and say, 'When Mommy was young and cute, she had a Japanese sugar daddy.'" I would try to reciprocate

when he gave me gifts, even if I couldn't financially match him. Like, after he bought me that Chanel bag, I gave him a pin of a frog.

Every few weeks or months, a town car would show up for an adventure. I wouldn't know where it was taking us: to a dinner where they'd flown in a chef from Japan to make us a blowfish meal; to a helipad on the West Side for a helicopter ride to Atlantic City and gambling; to a fondue restaurant where Tanaka would say, "Left side" and order the entire left side of the menu. For his birthday, he wanted my friend and me to come to Japan to celebrate. I was such a huge nerd that I didn't want to miss class, so I went to Japan for a three-day weekend over Presidents' Day. He took us to Kyoto and Tokyo and we rode the bullet train together. We went to this weird nautical themed drag show. I can't believe I didn't stay longer.

I told my mother all about Tanaka. She would ask, "Does he have tattoos? Is he missing fingers?" because she was sure he was Yakuza. He may have had ties to them, but I didn't know. I did find out at some point that he had a wife and kids, but I was his "fun girl." I'm sure he had other girls he slept with, but it was very chaste with us. There was a certain level of respect, because I was at a university. The closest he ever got was falling asleep in my lap on the helicopter ride back from Atlantic City.

I wore this red dress on that Atlantic City adventure. I probably bought it at the mothership Loehmann's in the Bronx, where you had to decide if you were going to get ice cream at the Carvel across the street *before* shopping, or *after*, and where all the ladies in the communal dressing room would loudly give their opinions on whatever you were trying on. That and Daffy's and occasionally Century 21 downtown were my go-tos in those days for out-of-character grown-up clothes. The great thing about wearing the red dress was that I would always be the only one with color. All the Japanese people around me would wear black and I'd be this big-haired Jewess with red lipstick and a red dress standing tall in the middle of everyone.

This went on for about a year, until my friend, who I depended on to translate, got a serious boyfriend who didn't like her having contact with the guys. I never had a chance to say good-bye to Tanaka.

I lived in a shit hole. I spent my weekends doing what I'd call my Harlem to Houston walks because I didn't have any money. I had the stupidity of youth. But my time with Tanaka was the only chance in my life where I got to—sort of—be a bimbo, even if I wasn't particularly good at it, and it was utterly delightful.

—AS TOLD TO EMILY SPIVACK

Jenji Kohan is the creator and executive producer of the television shows *Orange Is the New Black* and *Weeds*. She lived in New York from 1989 to 1991 and currently lives in Los Angeles but still has one foot in New York.

JENNA
LYONS

In 2011, something incredible happened: I was invited to the Met Ball. It felt frivolous and self-obsessed to think too much about what to wear, so at the last possible moment, I decided I should deal with it. Hanging in the hallway outside of my office was a wedding dress sample we'd never wound up making. I thought, "I can turn this into a skirt."

I had a men's cashmere sweater in my office that I'd wear when I was cold. I threw that on over the skirt and that became what I wore. Wearing a men's oversize sweater was the antithesis of the Met Ball.

The Met Ball red carpet consists of about eighty steps up to the entrance. When I arrived, I walked the red carpet to the top of those stairs. I looked back and saw that the skirt had lost hundreds of feathers. A sea of feathers was floating down the steps in my wake. Some poor guy was running out onto the red carpet trying to pick them up, because Beyoncé was coming up the red carpet next and no one wanted feathers from my skirt in Beyoncé's pictures.

The energy inside was so intense. It was exciting. It wasn't like watching from the sidelines. I was standing next to people who I had seen only in magazines and on TV. There was American royalty in the room.

I learned quickly that all the cool kids were hanging out in the bathroom—*that's* where the party was. Girls were helping each other get their skirts over their heads to go to the bathroom because people were wearing massive dresses, crinolines, and corsets. The boys would come in and be rowdy. People were sitting on the counter. No one could get to the sink. Everyone was smoking cigarettes, smoking around all these flammable dresses, not to mention priceless art. They've since cracked down and there's a guard in the bathroom now, but that year, the bathroom was the most insane situation.

This feather skirt left a trail wherever I went that night. After we left The Met, we drove to the party that Valentino hosts every year. I left feathers in the car. I left feathers

at that party. Then we went downtown to a place called Up and Down. Someone met me later who had been at the same after-party, and they had a cup of feathers from my skirt in their hands. I ended up at the Boom Boom Room until well into the early hours. I sat in the corner like I was nesting and left more feathers behind. I liked that I was leaving pieces of myself everywhere, that my skirt was disintegrating all night.

I felt like a goose in this skirt. But it was also the first time I really felt glamorous. It's so delicate and soft, yet it's vast. It's this massive undulating skirt. Trust me, you can't hide when you're wearing it.

—AS TOLD TO EMILY SPIVACK

Jenna Lyons was the president and executive creative director of J.Crew. She has lived in New York since 1987.

JIM
WALROD

I grew up in Jersey City listening to Flipper, one of the first postpunk bands. In 1984 or 1985, the designer Stephen Sprouse, who was like a god as far as I was concerned, had made this mash-up of a Flipper T-shirt to sell at his showroom on Sixteenth Street, in the same building as Andy Warhol's Factory. At the time people didn't really like that kind of music, so I was thrilled that he had made this T-shirt. I felt as comfortable wearing the shirt to punk shows in New Jersey as I did wearing it to my job at the boutique, Fiorucci, where people might not have known the band but recognized that it was Stephen Sprouse.

Working at Fiorucci was my first job in New York City. I got it when I was sixteen years old. I had just walked out of Bloomingdale's on Fifty-Seventh Street where I'd been trying to get a job as a stock boy. Andy Warhol and his assistant Benjamin Liu were standing on the sidewalk handing out copies of *Interview* magazine. Andy was like, "Are you a movie star or what?" goofing around like he used to do. I knew it was Andy Warhol. I told him I'd just applied for a job at Bloomingdale's but I didn't get it. Andy pointed across the street to Fiorucci and said, "Go into that store and tell them to hire you. Tell the woman at the cash register that I sent you. I'll stand by the window and wave to them. But you need to call me the day before they have their ten-dollar sale so I can tell you what I want." I walked in and told them Andy had sent me in. And I got the job.

The Stephen Sprouse crew hung out at Fiorucci back then, which made the T-shirt even more important to me. All these young artists and designers would showcase their work there. It was the first place where Kenny Scharf had a show. Isabel and Ruben Toledo first showed there. Jean-Michel Basquiat was supposed to but didn't have a chance. The coolest people I had ever seen would come to the store. Steven Meisel, Stephen Sprouse, and Teri Toye would come in together, like an incredible three-headed monster.

At the time, New York felt isolating. You had to be either the biggest scumbag or the smartest person within a group to make it here. There were a lot of go-go Wall Street types, bankers, and high-fiving white guys. But there were certain kinds of cultures that bankers couldn't get close to, things they didn't know about, and Stephen Sprouse was one of those things.

—AS TOLD TO EMILY SPIVACK

Jim Walrod is an interior designer and design consultant. He was born in Jersey City and has lived in Manhattan since 1987.

JOSHUA
STOKES

It was a windy night toward the end of winter in 2009. I was walking east on Twelfth Street from Fourth to Third Avenue. Two college girls were hanging out on the stoop of their dorm, so I slowed down to check them out. Then, out of nowhere, a big plank of plywood smacked down on the sidewalk in front of me, a four-by-six-foot piece of wood with screws sticking out. I froze. I looked around, trying to figure out where it had come from. Across the street I spotted a hole in some construction scaffolding about four stories up. The wind had blown this plank off the scaffolding and across the street, to land only about a foot and a half in front of me. "That was close," I thought and just continued on with my night. Nothing had much consequence at that time in my life.

Four months later, things were more topsy-turvy. I had no work. I was struggling in my relationship with my then-girlfriend, Kate. It was a hot July afternoon, and I was coming home from the farmers' market with a couple bags of groceries. I was walking down the same street where the plywood incident happened and I realized it had more gravity. If I hadn't slowed down to look at those girls, the plywood would most likely have hit me and caused serious damage.

I got to the corner with my groceries. The light turned and I stepped out onto the street and BAM! My groceries and I flew through the air. I landed on my back. I was staring into the sun and my brain said to me, "I think you were just hit by a car." I did this pat down of my body and a little shimmy, and everything felt like it was in the right place. I turned to the right and saw the car that hit me. I was filled with this flood of intense anger about the celery salad I'd eaten for lunch that day. I remember thinking, "This is fucking awful. This is the worst thing I've ever eaten." I stared at the car, thinking about the celery salad.

Then I turned to the left. I saw the watermelon I'd bought at the farmers' market, and it was broken on the street. Suddenly, all I felt was sadness. That sadness stemmed from not having let Kate know that I loved her and that I wanted to spend the rest of my life

with her. I stared at the watermelon and realized I had to propose to her immediately.

My brain came back into real time. I heard New York and I smelled New York and I felt this crazy intense burning all down my back and legs—because I was lying on Twelfth Street in July. People came over and asked if I was OK, telling me not to move. Someone brought me a bottle of water from the pizza place. Two other people handed me a piece of paper with their names and numbers, telling me I needed to sue the guy who'd hit me and that they'd be witnesses. But what I needed was to get off the pavement and into some shade.

I walked over to a bench by what used to be a Two Boots pizzeria. As I was walking over, I saw what had happened: An oil truck had rammed into the back of a minivan, and I had stepped in front of the minivan when the light had changed. The minivan hit me. I broke the windshield and left a big dent in the hood before it threw me in the air and onto Twelfth Street.

I sat down on the bench in front of the pizza place. An old Russian woman was sitting there, too. I'd seen her around, walking her Pomeranians or sitting with them at the bench. For whatever reason, I wanted to make small talk. And I never make small talk. "How are you doing today?" I asked. "I'm good. How are you?" Inside my head, I was like, "What are you doing?" I just said, "New York is a crazy town." And she replied, "It really is. Some guy just got hit by a car."

I called Kate. I thought, "I have to propose right now." She picked up. Before she could say anything, I said, "I'm OK, but I got hit by a car." Total silence. Then she said, "Honey, I'm in a meeting." I was like, all right, I don't need to rush into any big decisions right now.

By that time, a couple of firefighters had come over and were asking me if I was OK, if I wanted to go get checked out. I told them I was fine and that I just wanted to go home. Then I felt a whoosh in my stomach and I knew exactly what that meant. I was like, "Guys, I'm totally fine but I'm about to faint. But I'm fine. I'm just going to faint." I woke up and I was strapped to a big orange board, my head secured as they're throwing me into the ambulance. Sirens blaring, they rushed me to the trauma center at Bellevue, which is an eclectic place, to say the least. About eight doctors were waiting for me in the emergency room. They took off all my clothes, cutting up the leg of each pant leg and cutting off my shirt. While they're poking and prodding me, I asked them not to throw away the pants, because they had been my dad's from the army.

They decided that I was OK, draped a sheet over me, handed me a shopping bag with my pants, and wheeled me out into the waiting area. I just wanted a hug from Kate and to tell her that I loved her. I called her to tell her I was at Bellevue. She flipped out, because she hadn't realized how serious it was, and rushed over.

Meanwhile, I had to wait for about three hours because a guy who must have been the hospital's wardrobe specialist—a tall, skinny guy with flamboyance and perfect posture—was trying to find clothes for me to wear, pretending he could find something that would make me look nice. He ended up bringing me XXXL sweatpants and a medium T-shirt.

No question that I looked like a crazy person walking out of the hospital holding up my too-big pants, wearing a shirt two sizes too small, and carrying my ripped army pants in a plastic bag.

Three things came out of that day:

1. I don't walk down Twelfth Street anymore.
2. I have never since eaten an unsatisfactory salad.
3. Two weeks later I proposed to Kate at KFC, and we've been happily married ever since.

I still wear the pants that were cut off me. My friend, a seamstress, sewed them back up, and now they're like Michael Jackson skinny jeans, but from the army. They look better stitched up anyway.

—AS TOLD TO EMILY SPIVACK

Joshua Stokes is happily married to Kate and they are raising two daughters in Brooklyn. He has lived in New York since 1999.

KIMBERLY DREW

I picked up this sweater from a free box when I was visiting my alma mater Smith College shortly after I'd graduated. I brought it back with me to New York and wore it every day because it was like walking around in a blanket. I loved this cute ugly thing.

Then I broke out in a crazy rash on my chest. I put some topical cream on it and ignored it. I thought the itchiness would go away eventually. My ex was like, "I had bedbugs and this seems like bedbugs." "That would never happen to me!" I told him. Then I was changing my sheets and spotted a bedbug. I knew immediately it had to be the sweater. The rash had originated on my chest and the sweater was the most recent thing I'd gotten.

I freaked out, told my landlord, and spiraled downward from there. I was strapped for cash, my roommate, who was a costume designer, kicked me out because I had bedbugs, the relationship I'd been in was eroding, and I had to take care of this situation to the best of my ability. It was definitely a holy shit, this-is-real-life moment. I realized that having bedbugs is real and can happen—they aren't just some distant fear.

So many of us in New York are interested in appearing normal, as if everything is totally OK. But getting bedbugs made me understand that reaching out to people and letting them know what's going on is the only way to survive in the city. Once I came out as a person who had bedbugs, I learned about other friends who had had them, too. There was a task force of people who were like, "You need to get these strips. You don't need to wash everything. You do need to put everything through the dryer;" simple things that aren't common knowledge because of the stigma—a stigma against a thing that's totally common.

After the ordeal, one of my good friends who'd also had bedbugs took me out to a cute lunch in Astoria and made me cupcakes. Two young New Yorkers going through some shit. She told me I'd handled it much better than she had. She'd gone home to Florida and pretended it wasn't happening.

Having bedbugs also taught me about the kind of friend I wanted to be to other people. My moment of crisis made me an awful bitch. It was one of the meanest times in my life, a time I'm not proud of. But, two years later when I got a cryptic message from a friend that said, "I heard you had bedbugs," I was like, "Yeah, girl, these are the things you need to do." I rose to action. I was like, "How can I be of service to you?" I'm very much the friend in my friend group who people go to when they're going through it. I'm proud of that. I know what it's like when you don't feel comfortable going to people's houses, when you don't want to sit on the subway, and you only want to talk to people who understand what you're going through. It's important to know there's someone who's gone through the thing you feel totally ostracized by.

The sweater became a formative garment. After the bedbugs, I was tentative about wearing it for a while, because it was the source of all the drama. I thought I should burn it, but I still loved it. I washed it, dried it, and decided to keep it. Now I wear it proudly.

—*AS TOLD TO EMILY SPIVACK*

Kimberly Drew is the social media manager for The Metropolitan Museum of Art and the creator of the Tumblr blog "Black Contemporary Art." She has lived in New York since 2012.

KITTEN
NATIVIDAD

I first met Katy K in 1982 when she came with her boyfriend to see me perform at Show World in Times Square. She knew about me because I'd acted in my then-boyfriend Russ Meyer's movies, and she was a fan. After shows, I'd usually have a meet-and-greet where I would sign autographs and sell my pictures. I saw this woman sort of hiding around the corner and peeking her head out, watching me, and being shy. I also noticed that she had big breasts, just like me, and that she was wearing a beautiful dress. I complimented her on the dress, and Katy K said, "Oh yeah, I make them. I was wondering if you were interested in getting one?" And I said, "Yes, in every color!" So she made me about twelve of them. And we became best friends. I would stay at Katy's house in New York whenever I'd come visit. Usually I'd stay for a few months at a time.

I loved this dress because it was wash-and-wear and I could roll it into a ball and it would be fine. What was most likely to happen was that the dress would get stolen. I'd take it off to do my show and try to hide it in the restrooms, but people would take it. Thank God I always gave my purse to a friend!

This was my cocktail dress, my party dress to look elegant. To look hot and sexy. It's what I would wear into the venue. It became my uniform—if something looks great, why screw around wearing other things? I would wear it without nylons, panties, or a bra, which made it easy to slip off to put on my costume. To perform, I'd usually wear a G-string, then fishnets, and then another two G-strings, which I would eventually take off. I would also wear a bra and a gown, feathers, earrings, and a necklace.

I would do different types of shows: burlesque at places like Danceteria, dancing in a cage at Limelight wearing a bra, pasties, and blue paint or something, or doing a striptease at Show World. Times Square was really nasty then. It was nothing but gay porn, hetero porn, strip joints, a lot of drugs being sold on the street, and a lot of whores. It was filthy and dirty, and I just loved it! It was fun! There were these bars where all the strippers were

trans and we'd go see a show after mine. Seeing them, I'd be like, "God, I've gotta wear my hair like that," and then I'd buy a wig and have it combed and styled like one of the strippers.

Disco was a big thing then. Everyone would dance and it was always a big party. There'd be a break and I would perform for an hour. The DJ would play my music and I would dance, stripping, teasing, and taking it easy. Finally I'd take off my clothes and throw them into the audience. When I performed, the club had a chance to sell drinks, because when you just disco disco disco people don't buy drinks. They just keep dancing!

I got into this because one day I saw a woman with a big butt and tiny pointy breasts leaving my neighbor's apartment across the hall. I asked my neighbor who she was. "That's my sister. She's a go-go dancer and she makes $300 per week!" I thought, "I could do that!" I was only making fifty dollars a week as a keypunch operator. I found out that she'd gotten the job by answering an ad in the newspaper. She showed me the ad for the agency, I went in for an interview, and I got hired. They asked, "What's your name?" I said, "Frances." "Unh-unh," they said. "You're so sweet and shy. You're so kittenish. We'll call you Kitten." And it stuck. But they also wanted to change my last name, Natividad. It's my real last name from my father, who was Mexican. They tried to convince me: "Number one: Hillbillies on the road do not like Mexicans. Number two: It's a mouthful." And I said, "Number three: They're gonna dream about me and I'm keeping my last name."

I began go-go dancing in a cage when I was young, around twenty-one years old. That was in Hollywood. Then I started watching some of the older women who were not as wild and crazy. They would tease. I thought, "That's what I want to do." I had to learn where to get the wardrobe, where to buy the clothes, how to find the right shoes. I'd watch the girls, copy them, and then make it my own.

I won Miss Nude Universe in 1973 and 1974, and from there I got a manager and an agent so I always had gigs. I acted in Russ's movies. But I still had to do press. They had to promote me. So I would do these bikini walks in high heels. I would travel from city to city, and men would come out of their offices, out of the stock exchange, and follow me through the streets to the club where I'd be performing. I worked it, honey. Nothing was given to me. Nothing. In New York I did a bikini walk where, once I was done, I got in a cab with my manager. The cab got turned on its side because the guys were pushing it, trying to get me out. It was a riot!

I loved it. I'm not gonna lie. And I loved the money. I loved the fame and the adoration from men. Bring it on! On my birthday, they would bring me flowers and gifts and money. But in those days, we were looked down on as whores. How dare we get naked in front of strangers! Sometimes I felt like a piece of shit, because I'd go to parties and people

would ask me what I did and I'd lie and tell them that I was a secretary. And my mother— I just wanted her to care. But she was emotionally abusive. She told me I was ugly. Didn't talk to me for about five years. But did I quit? No! Performing brought something out of me, you know? Something I hadn't gotten, something that I wanted.

—AS TOLD TO EMILY SPIVACK

Kitten Natividad, Miss Nude Universe 1973 and 1974, is an exotic dancer, porn star, and actress who appeared in many cult films directed by her ex-partner, Russ Meyer. She lives in Los Angeles.

KYP
MALONE

I stopped by Miller's Tavern in Williamsburg to get a cup of coffee. When I walked in, the bartender was shooing away this little bird he'd found behind a bottle of whiskey. The bird just kept coming back inside the restaurant and standing under the table where I was sitting. I wrapped it in a napkin and brought it to the park. Ten minutes later it was back in the restaurant. I went home to get a shoebox and returned to put the bird inside of it. We determined that the bird was probably sick and maybe looking for a place to die.

I called wildlife rescue in New York, and they told me that there was no place to take it at that time. They suggested I get the bird some food. So while carrying a bird in a box with holes poked in it, I walked around Williamsburg looking for bird food.

I was walking by a shop called Lavai Maria on North Fifth Street and saw this woman working who was so striking that I had to go inside to talk to her. I wasn't buying dresses for anyone at the time, so I didn't have a reason to be in there. It was clear to both of us that I'd walked into the store to talk to her. She asked me what was in the box and I told her I was carrying a bird. We talked for a while. I stayed too long and I ended up buying this scarf. I learned she had a partner. Eventually I went back to making the bird comfortable.

The bird died later that day, after I'd found it birdseed and a cage. I buried it in Grand Ferry Park. Miller's Tavern is no longer there. The boutique closed. So much has changed in the sixteen years I've lived in the neighborhood. So much that feels new also feels alienating. It's easy to feel like you're from another time in New York, even though I only arrived in 2000. I've started to understand what it would be like to be a ghost. But the girl in the shop has become one of my best friends, and I still have the scarf I bought that day in 2011. And I'm still here.

—AS TOLD TO EMILY SPIVACK

Kyp Malone is a musician and a member of the band TV on the Radio. He has lived in New York since 2000.

LENA
DUNHAM

My mom is obsessed with Century 21. It's like a religious location to her and her sisters. My whole childhood was spent following my mom around Century 21. To me, it was the most glamorous, important place. Everything great came from there.

When I was in eighth grade, at the height of Gaultier, my mom came home from Century 21 with this Gaultier ball gown. I was so into him that my mom would buy me these dumb mesh shirts just so I'd have *something* that said "Gaultier." I remember having diarrhea on a school trip and being like, "At least I'm wearing Gaultier!" So to have a Gaultier ball gown, I thought you had to be a millionaire. My mom had found it in the European designer section marked down, like, 200 percent. It's a hideous brown with pinstripes and layers of tattered tulle, and I thought it was the most beautiful thing I'd ever seen. I'd try it on and wear it around our house, but my mother had forbidden me from borrowing it.

When I was twenty-three, two of my best friends since preschool, Joana and Isabel, and I started a web show called Delusional Downtown Divas based on our shared upbringing in Tribeca with artist parents. Together we made thirty short episodes of this weird, abstract, Dada show about people trying to make it in the art world but who didn't actually make art.

Art people found it funny and started to watch the show. We got hired to do ten spots for the Guggenheim because the artist Rob Pruitt was doing a fake art awards show at the museum. For the piece, we did parody interviews with ten artists. *New York* magazine wrote an article about us, and we thought it was the greatest thing that ever happened, that our lives were truly taking off. Soon after, we got asked to do an event that involved artists making cakes and serving them in cool ways. Rob Wynne made a cake that looked like a giant mercury spill, and his vision was that we would sit onstage and consume the cake as the Delusional Downtown Divas.

Our vibe that night was supposed to be very Marie Antoinette. We sprayed our hair blue and made it really high. My mom was out of town, so I decided that I would take the Gaultier ball gown, wear it, and return it, and she'd never know it'd been gone.

Once we were dressed up and onstage, we realized we were never going to do the performance art thing again. People were looking at us in a sad way, like when you go to a movie premiere and somebody has been hired to dress up as a *Star Wars* character and you're like, "I know that's your job and I'm not trying to be condescending but it seems like a bummer to have to do that." We were just not regarded as the performance artists we thought we were. No one paid attention and we were getting sadder and sadder. Also, I had been on this intense diet, so I was feeling a lot of shame for eating cake in the first place and that shame turned into me stuffing my face with more cake.

I threw up in the bathroom from overeating. It was already a bad night, so after I changed out of the dress, I texted this guy who I'd been dating on and off who was truly a hellhound and was like, "Can I come over?" I figured I might as well have sex with this person I knew hated me. I ended up going over to his place, and it was one of three times in my life I've done cocaine. I thought I was going to die.

The next morning, I left his house hungover. I got cold chills down my body when I got outside and realized I had left the Gaultier dress inside his apartment. I rang his bell over and over, but he was too fucked up to wake up and answer. I waited by his apartment for maybe two hours. Finally, his brother left for work and pitied me, and he let me back into the apartment. I snuck into the guy's bedroom, got the dress, and brought it back home.

I felt so much guilt, shame, and anxiety that I had to tell my mom I took the dress. I was like, "Mom, I overate, vomited, did cocaine, and wore your dress." She was like, "I don't even want the dress anymore. You can have it." It was a great win. My performance troupe had broken up, I had messed up my diet, and I was in love with a guy who had made it clear that he didn't care if I lived or I died. But my mom had told me I could have the Gaultier dress.

Let me be straight: This dress doesn't look good on me. It looks much better on my mother, who is six inches taller and at least twenty pounds lighter. When I wear it, I look a little bit like those French prostitutes at the beginning of *Les Mis*. But I've worn it a bunch. I've worn it for Halloween to be a *Moulin Rouge!* lady. I've worn it to a cool Bushwick-y fancy-dress party. I wore it to a movie premiere. It's had a whole beautiful life with me. I don't keep a lot of crap. I don't keep the "but these are the jeans I lost my virginity in!" jeans. This dress, though, will be a part of me until the day I leave this planet.

—*AS TOLD TO EMILY SPIVACK*

Lena Dunham is a writer, filmmaker, and native New Yorker. She and her partner, Jack, split their time between Brooklyn and Los Angeles.

LEVONDA
BROWN

These shoes were given to me at a women's shelter. I had one pair of shoes before that, but they were falling apart and I had to throw them away. The shelter had a closet where you could take stuff that people donated. I'm a size six, but they only had size five and a half, so that's what I took. At first, they hurt a bit because they were too small. But I wore them every day during the summer and fall, so they stretched out.

When I was first homeless in New York, a nice lady told me to call 311 and that's how I was directed to a shelter. I stayed in a few shelters with my three-year-old daughter, Harmony, from May through July and September through December 2016. One shelter was in the Bronx, one was in Harlem, and one shelter was in Brooklyn—that's where I got these Air Jordans.

Every day, I would put on these shoes and head to the library. I was working on a book, and I'd spend time writing and reading. Then I'd go outside and pick up trash at a park, because I don't like seeing kids play in trash. Since I couldn't afford child care, Harmony would stay with me.

The shoes aren't in the best condition, but everyone loves Jordans, so people recognize them. I could have on a blouse and you'd think I'm cute and then look down at my shoes and think, "What's going on?" But I had no choice.

I'm not in the shelter system anymore. I didn't like the system, but when you have a kid and you're a single mom, you need the help. Now my daughter and I are living with a friend in Connecticut, but I still come into the city to sell jewelry. I take the train to wherever I think people will be welcoming. I walk into nail salons and hair salons and say, "Hello, ladies, would you like to take a look at anything?" I think my daughter is the reason I get customers. She'll ask people if they want to see the chokers, which are a bestseller. You can make money doing anything in New York. There should not be a day that you don't have a dime in your pocket.

It's not even about material things for me because there was a time when I had money—when I could buy shoes—but it wasn't very important to me. What's more important is not giving up on myself. These shoes remind me to not give up.

<div align="right">

—*AS TOLD TO EMILY SPIVACK* ·

</div>

LeVonda Brown is a writer. She moved to New York in 2016 and currently lives in Connecticut.

LISA
BONANNI

I started dating for the first time when I was in my forties. I got married when I was nineteen, had my daughter when I was twenty, and got divorced a year later. When I wasn't being a single mom, I was going to school or working. I went out with one guy for six years and then another guy for six years, but I never dated.

I'd always wanted to live in New York, and so had my daughter. In 2014, when she was twenty-four and I was forty-four, we moved from Philadelphia to New York together. My daughter had friends and met people quickly, but I didn't know anyone. I would walk around the city, going to places by myself—cafés, comedy shows, Central Park.

To meet people, I went on Match.com. Some weeks, because of my flexible work schedule, I'd go on five or six first dates. I wasn't looking for a husband. I wasn't desperate. It was more of a curiosity and I was new to the city.

My first-date uniform was always the same shirt, same pants, and same wedge sandals. My daughter would see me putting on that outfit and say, "You're going out again?" Or she'd say, "Be careful." A couple of times when I was on a date, she texted me, "Where are you?" It's like our roles were reversed.

In the beginning, the dates gave me confidence because I realized I could talk to anyone. Then there comes a point when you're like, "Oh, God. Another dud."

I met this businessman on the Upper East Side for dinner and drinks. Afterward, we drove to a town in New Jersey because he wanted to gamble. He must have started drinking beforehand, because he was swerving all over the road. I don't know why I went with him. I was a nervous wreck.

One guy was selling wholesale jewelry at the Javits Center, and he asked if I wanted to stop by while he was working. It turned out he really wanted me to help him work. I stood behind the counter for a few hours like, "Why am I doing this?"

Another time, I took the train to Bronxville for a date. My friend said, "Make him come to you," but I thought I'd see what Bronxville was like. I met him outside a Starbucks, and I don't want to be mean, but he wasn't George Clooney—the guy didn't look like his online photo. Then he said, "You know, I'm not feeling good." He didn't want to have dinner. I felt shitty the whole train ride home.

But some dates were great, especially when I got to see the city. I had martinis for the first time at Bemelmans at the Carlyle Hotel. I heard jazz at Birdland, explored Battery Park, and walked through The Metropolitan Museum. And I did meet one guy who I dated on and off for a year.

I probably wore this shirt on all these first dates because it fit well and was attractive. It might sound silly, but how the shirt made me feel is how I want to feel in a relationship. You want to click, to feel comfortable, and to feel an attraction. I learned that you date according to how you feel about yourself, and it was in this shirt that I felt most comfortable.

—AS TOLD TO EMILY SPIVACK

Lisa Bonanni is a pharmacist. Originally from Philadelphia, she moved to New York in 2014.

MARK
JACOBSON

I dropped out of Berkeley and returned to New York City in 1972. Sooner or later, you would become some brilliant author, painter, or actor, but until that happened, you had to make money. Either you could be a waiter (and I was too absentminded for that) or you could be a cab driver. Driving a cab was a million times better, because you weren't working at a place where the boss could keep tabs on you. Plus, driving this Checker cab around New York City was considered a totally legitimate bohemian job for an early-twentysomething white guy.

I'd show up at the garage—Dover Garage on Hudson Street—at 4:00 P.M. to work the swing shift. To earn enough for the week, I'd drive for around twelve hours, three nights a week. I could get by on $200. With $250 per week, I would be set. I always drove at night because I didn't like the traffic, but it was much more dangerous, so I needed some protection. My leather bomber jacket was my armor, my illusory protection. It was my tough-guy teddy bear, the toughest article of clothing I had. It also made me feel the most physically confident in case the inevitable happened, as it did a couple times: getting held up at gunpoint. If a guy pointed a gun at me, I needed to have something that felt like it would ward off bullets.

It had to be a bomber jacket, not something fashionable like a motorcycle jacket. And it had to be made of thicker cowhide leather. Over the years, I've probably gone through seven or eight of them. I wouldn't spend more than ninety-nine dollars, and buying a used one was preferable because it was already beaten up in just the right way.

Your job was to allow people you didn't know to sit behind you in your cab. All there was between you and the passenger was a *farkakte* glass thing. That glass made you feel claustrophobic. You could open it so that you could breathe, but then you were vulnerable. If they were going to take out a gun, point it at the back of your neck, and tell you to give them your money, you wouldn't have much protection.

Driving a cab in the 1970s was different than it is today. It was considered bizarre to drive a taxi above Ninety-Sixth Street. Nobody in a million years would ever go to Brooklyn. And no normal cab driver—or New Yorker, for that matter—wanted to be out after midnight.

Maybe it was crazy, but I loved driving my taxi in Harlem because nobody expected you to put the meter on. People would get in the cab and tell you where they wanted to go. You'd say, "Three bucks," and they'd give you three bucks. If you didn't put the meter on, you got to keep the money instead of giving half the fare to the cab company.

Going above 125th Street felt like a real Wild West situation. There were gigantic areas of abandoned buildings and hundreds of junkies standing around. It was nuts, like going to a pioneer town where the cowboys would go. I was a real movie fan, Spaghetti Westerns, Sergio Leone stuff, but I wasn't going to wear a stupid fucking cowboy hat in New York City like the guy in *Midnight Cowboy*. With my bomber jacket, I could go uptown and feel like I was riding the plains, more or less.

Later in the evening, I'd start picking up "night people." It was the beginning of disco, and people coming from disco clubs were who I wanted as passengers. They were so tired that they'd take a taxi over the train. Then there were these gay leather bars on Twelfth Avenue before they tore down the elevated West Side Highway. I'd hang around places like Mineshaft, skulking around at two in the morning, hoping to get one of these guys in leather jockstraps who lived in Englewood, New Jersey, because you doubled the meter if you drove outside the city. That fare would make your night.

Sometimes I'd cruise uptown on Amsterdam or Broadway around Eighty-Sixth Street thinking, "OK, I'll drive for another ten or twelve blocks and then turn around." I'd pick up anyone—unless they were holding an M16 or something—but occasionally, I'd make a mistake. Once it was around midnight and this guy said he wanted to go to 125th Street and Eighth Avenue. To me, that was reasonable, because on 125th Street there were people around. "OK," I told him, but once we were driving, he told me he wanted to go to 145th Street. 145th was a no-go area, so I was thinking, *fuck*. Getting someone out of your cab when they're already in it is way more difficult than not letting them in to begin with so I took him up to 145th Street. He got out of the cab and knocked on my window, like I should roll it down so he could pay me. He gave me what he owed and then he pulled this gun and stuck it in my face. He said, "Give me the rest of your money." He was already out of the cab so I just slammed on the gas and went through about ten lights to 110th Street, where I pulled over so I could just breathe hard.

When someone pulls a gun on you and sticks it in your face: That's a meaningful experience. It's not something that happened every day, but it was something you knew could happen. That danger and uncertainty made it the job for me. I was born in Brooklyn, I grew up in Queens, and I knew the city. I felt like, "I'm entitled to this territory as much as you are." I was just riding around my hometown, picking people up, and I had to face the repercussions. Wearing the leather bomber jacket was all part of it.

—AS TOLD TO EMILY SPIVACK

Mark Jacobson is a writer and journalist whose 1975 *New York* magazine article, "Night-Shifting for the Hip Fleet," was the basis for the television show *Taxi*. He is a native New Yorker based in Brooklyn.

MARTY MARKOWITZ

Just about everyone in Brooklyn supported the Brooklyn Dodgers. Our enemy was the Yankees. After all, the Brooklyn Dodgers had won many pennants, but when they faced the New York Yankees, they always lost to them. Always.

I bought this hat the year after they finally won the 1955 World Series. It is especially important to me because my father, who lived for my two younger sisters and my mother, also lived for the Brooklyn Dodgers. Every waking moment he would listen to Dodgers games on the radio. Or, on his half-day off from waiting tables at the kosher delicatessen, he would go to games, since Ebbets Field was only three blocks from where we lived. My dad died in 1954, when I was nine years old, just one year before the Dodgers won the World Series.

Even though we grew up in poverty, my friends and I would go to Dodgers games. We would sneak in after the first inning. It was different back then. There was no security. There were just ticket takers, and after the first inning, no one really cared. You just walked in. Not often, but every now and again, I would skip out on school and watch a game, especially if the Dodgers were in contention.

When the Dodgers left Brooklyn in 1957 for Los Angeles, we felt abandoned. It felt like we lost a part of our lives, at least for kids my age, because the team consumed our passion and our identity. I even went to a rally to save the Dodgers at Brooklyn Borough Hall when I was eleven or twelve years old. They were what we thought of ourselves—come-from-behind, "youse guys," working stiffs. The best way to put it: The New York Yankees were the aristocrats and the Brooklyn Dodgers were the working people.

The fiftieth anniversary of the Brooklyn Dodgers World Series win was 2005. As borough president, I went around to Little Leagues throughout Brooklyn wearing this hat and throwing out the first pitch. I'd say to teams that this was an important year, that fifty years ago the Brooklyn Dodgers beat the dreaded New York Yankees. Instead of the

children cheering, they booed me. That goes to show how much the world has changed. Those kids lived in Brooklyn but were Yankees fans because they hadn't heard of the Dodgers. When they'd boo, I'd always turn to God and say, "God, forgive them. They know not what they say." Of course, the parents would laugh. Or if the parents were too young, the grandparents would laugh.

The last time I wore this Brooklyn Dodgers hat was to Yankee Stadium. Mayor Bloomberg had invited the borough presidents to a game at the renovated stadium. Listen, other borough presidents went, so I had to go, too. I chose to go. I had been to Yankee Stadium only one other time in my life. It was enemy territory. I walked in with the hat on my head and I started getting booed there as well! As much as the Brooklyn Dodgers fans had hated the New York Yankees, I couldn't believe that these Yankees fans were still hateful. But then I realized that they thought the B on my hat was for Boston, not Brooklyn. They thought I was a Boston Red Sox fan, when in fact, that was the last thing on my mind.

—AS TOLD TO EMILY SPIVACK

Marty Markowitz is a former borough president of Brooklyn, a position he held for three terms, from 2002 to 2013, following his twenty-three-year run as a New York State senator. A native New Yorker, he was born in Brooklyn, where he still resides.

MATT
CAPRIOLI

I moved to New York from Alaska in October 2012, right around the time of Hurricane Sandy, with $1,000 in my bank account. I left Alaska hastily because, in addition to the homophobia I encountered there, my boyfriend had broken up with me. He was the first guy I loved. All my self-esteem was in his hands. Like it is for many people I've since realized, moving to New York was a reaction to heartbreak.

I was eager to join the workforce. I had just finished a BA in English literature, had some journalism experience, and thought I was going to become a journalist. I applied for hundreds of jobs. I got one interview, at the *New York Times*, but it didn't work out. I was crushed about that and crushed that I couldn't get a job. I had done everything that was expected of me. I was an honor student who had taken all these AP courses, I'd gotten good grades, and I'd gone to college. I thought I had prepared myself for New York because of what I had read and watched on TV. I didn't think I'd be a country bumpkin, but I was.

I joined this website, Adam4Adam, which is like an aggressive, sleazier OkCupid. It is supported by pornography ads, and it's meant mostly for hookups. But I met friends on the site, like an art history professor who introduced me to all the museums in New York. He taught me that MoMA was not called "The MoMA," that Harlem wasn't called "The Harlem," and that Houston Street wasn't pronounced like Houston, Texas. He led me out of these stumbling blocks, almost like a Gandalf figure. He even had a white beard.

Once in a while on Adam4Adam, people would ask, "Do you want to have sex for $200?" After not being able to get a job, being rejected by the publication that I loved, and having only forty-seven dollars left in my bank account, I thought, "Why not? It seems like a good deal."

One of the guys who first approached me I nicknamed Joe of Chelsea, because we always met in Chelsea. He was super nice and very ordinary, like an eighth-grade math

teacher in his mid-forties. He wore a white button-down shirt, Dockers that hit above his ankles, and Reeboks. He showed me a kindness that I didn't get from the regular world, the supposedly "legal" world. We met every Saturday. I thought, "Damn, if I can meet people who will accept me, pay me, and who seem to like me, then why don't I just do that and stop applying for jobs that I am apparently unqualified for?"

At the time, I was working in the stock room at the American Apparel on Canal Street, and I remember the whole place smelled like a fart. I got paid nine dollars an hour and it felt unjust especially because there were men out there who would pay me $200.

I found out my rate was on the low end, so I started asking for $260. It's even more validating when someone looks at your face and says, "You could actually charge $350." My price kept getting higher. I only took on clients I liked. I enjoyed the sex. I enjoyed the conversation. If they played their cards right, they probably could have done me for free.

I saw my clients in the same way I see the point of literature—to look inside someone's soul and see their potential, the magnitude of their existence. I tried to look past physical features. Because I believed that people were more important on the inside than on the outside, I was able to have sex with anyone. It's funny that my English major, in a peculiar way, prepared me for work as an escort.

I would pass the Leather Man every time I'd visit a friend on Christopher Street. I always wanted to go in but I was nervous. I finally did. I didn't look the store attendants in the eye. I didn't want to browse around. It felt like going into a liquor store, where if you spend too much time looking, the owners either think you're going to steal something or judge you on your wine choice. I had to get in and out. I picked up this jockstrap—or whatever you might call it—that was hanging on the wall and dropped it on the counter.

Being in the Leather Man was a study in contrasts. At the time, I was twenty-two and I looked like a twink: doe-eyed and innocent, annoying and airheaded. I was the opposite of what I assumed was their clientele: cubs, bears, or otters. The man at the register was this six-foot-three, beautiful, blond muscular guy. When I purchased this jockstrap, he looked at me with a slight grin and some mixture of pity and hope. At the time, I was slightly offended, like, "I don't need anyone to look out for me. I know exactly what I'm doing. Fuck you." In retrospect, it was nice.

I started posting ads online with a photo I'd taken of myself from behind wearing the jockstrap with these over-the-knee socks that said, "Gay." The clients I met liked the picture and they liked the jockstrap. It shapes your package, and the two straps in the back support your butt. The style of the straps offered my butt like it was a basket of bread.

Before I bought this, I would wear Hanes. I didn't like spending money on what I thought were frivolous things, like underwear. Then a friend said, "You're gay. You need really good underwear." That comment encouraged me to get nicer, sexy underwear, which changed the way I felt about myself.

Eventually, getting paid hundreds of dollars to have irresponsible sex took its toll on me. I had been escorting about three times per week for ten months. I don't want to denigrate sex work in any way, but if you escort too much, you get disconnected from the rest of the world. I was not relating to people and I wasn't growing as a person. I'd stay in my room all day, read and write, which was fun, and then I'd have casual sex with people, which was also fun. But I'd day-drink and I just stopped trying. I'm also not good at keeping secrets, so having to constantly lie to my family about my job got to be too much.

I thought that having another degree would help me get a real job, so I went back to Alaska to get a degree in psychology. I told myself I was leaving New York to study, but really I was trying to figure out who I was. A year in Alaska thinking about my actions helped ground me and got me ready for round two. I moved back to New York in May 2014.

Coming back for the second time, I was far more stable. The first time I moved, I was a mess, and I wanted to escort, in part, to prove that I was worth something. It was an unhealthy crutch after a breakup. Now, at twenty-six, I focus my energies differently. I'm studying for an MFA, I have a good job, a good place to live, and a loving partner of three years. I'm getting to where I wanted to be. I thought I'd get there after two months in New York, but it's taken me four years. And it's taken a route I never could have predicted.

—AS TOLD TO EMILY SPIVACK

Matt Caprioli is a writer living in New York. Originally from Alaska, he first moved to New York in 2012 and returned in 2014.

MEL
SHIMKOVITZ

I landed in New York City in 2001, more or less from Kansas. I'd never been before, not even for a visit. My mom was from Flatbush and she hated New York. Sight unseen, I moved into an apartment in Astoria.

I would go to Central Park by myself some days. I'd sit in Sheep's Meadow listening to my Discman, pretending to write in my journal, watching these groups of friends. I'd think, "I could be your friend. I'd be such a good friend. I'm so funny. I'm so loyal. Do you want to be my friend?" I was lonely, twenty-two, and broke, despite the $20,000 a year I made duplicating VHS tapes at Miramax.

In September 2001, I had my first bit of vacation, so I booked a ticket to New Mexico. Two of my best guy friends from Kansas were living in Taos, off the grid in a Flintstone-type house. No running water and electricity only from solar power. I'd never been to the Southwest, but I'd always been obsessed. I had an amazing week. On September 9, we drank a bunch of mushroom tea and I spent eight hours pacing around, thinking, "Did I piss myself? Are those gremlins?" And then we did what they did every night—watch the movie *Friday*, twice, because they had just enough electricity to watch two movies a night. These two white boys from Kansas had memorized every single line of *Friday*.

The next day I got on a plane, a red-eye back to New York. I was seeing friends that night, and my plan was to announce that I was leaving the city. That I'd found myself in the Southwest and was going to live off the grid in New Mexico to, I don't know, be a writer, take drugs, be super tanned, and get dirty. On the morning of September 11, I was on the N train going over the Queensboro Bridge. I heard someone yell, "Oh, fuck!" and everyone looked up. The first tower had been struck. And then we went underground. I got off the train a few blocks from the towers at South Ferry, worried about getting to work on time. Not long before the towers fell, I spotted these Orthodox Jewish men already covered in dust, praying, and I realized they were saying the Mourner's Kaddish.

After that, I became a New Yorker. That night, when I finally made it back to Astoria, a whole bunch of people from Kansas who had also ended up in New York gathered at my apartment. Suddenly, I was like, "I do have a community here." My roommate and I held court for a week. I knew I wasn't going to leave.

In 2007, I bought a bunch of land in New Mexico on the Rio Grande to build a house. Some summers I would be there for three or four months working on it. New Mexico became my fantasy place, my comfort. That was the way I could live in New York and deal with being a shut-in, living and working in my apartment.

I started collecting bandanas and wearing a lot of Navajo-inspired southwestern gear, bolo ties, and Stetson hats. My wardrobe became what made me feel calm and in my fantasy world. Literally wrapping myself in these talismans reminded me of the pink open skies, the unaggressive colors, the smell of the desert, the way I could expand there. I felt like I could be huge whenever I closed my eyes, so long as I was wrapped in these things. It didn't matter if I was sandwiched in a subway car, because I had my gear, I had one foot in the desert.

Part of my wardrobe included these cowboy boots. But the cowboy boots were problematic in New York, because they were not ideal for black ice or subway sludge. I was always skating around, trying not to fall but unable to let go of my fantasy uniform.

One summer when I was working on my house in New Mexico, these Mexican teenagers who would herd sheep rode by on an ATV. They didn't speak English and I didn't speak Spanish, so we smoked cigarettes and made charades at each other. As they got back on their ATV, I noticed their cowboy boots. They had outfitted them with big, toothy hiking boot soles, probably because they were trudging through the mud during New Mexico's monsoon season. I realized that those hiking boot soles on my cowboy boots would be perfect for walking around New York in all kinds of weather.

I got back to Brooklyn and brought this pair of boots I got off eBay for ten dollars to my shoe guy, an eighty-year-old Chinese gentleman on Grand Avenue off Lorimer in Williamsburg. When you'd walk into his store, you'd immediately get high off the smell of glue—I don't know how he had done it for so many years. He didn't speak much English and I didn't speak Mandarin or Cantonese, so we also made charades, although this time, I was trying to explain to him that I wanted Vibram soles attached to the cowboy boot soles. He just didn't believe that's what I wanted, but I was emphatic. I kept sketching it until he got it. And he did it. That way I got to keep wearing cowboy boots around New York.

I feel bad saying this, but like every love affair, living in New York was tumultuous. While I was out west, I'd sublet the rent-controlled apartment I had moved into in

Williamsburg. And every single time I returned to my apartment after a stretch out there, I would start weeping. Even though I had made a great life for myself in New York, I'd be bereft at being back. I would open my suitcase and take out whatever new rocks or sage I'd collected. I'd put away these special things, setting up my house to look as Sam Shephard as possible to get back into that space. The Southwest became such a muse for me.

These boots allowed me—even now, living in Los Angeles—to be in my fantasy, to be one thousand miles away, in a place where I was the only person and there was room to roam. Where all I had to worry about was getting water and food for that day. That said, I don't go to New Mexico for long stretches like I used to, because I'm living my actual fantasy every day in LA. And I don't need to wear these boots with thick, toothy soles now that I'm here. There's barely any weather. But I still wear them every day, because they make me feel tough, like a mutant biker with an elegant masculinity. I don't feel like myself without them.

—AS TOLD TO EMILY SPIVACK

Mel Shimkovitz is an artist, actor, and writer living in Los Angeles. She lived in New York from 2001 to 2012.

MICHAELA
ANGELA DAVIS

It wasn't the first time I was photographed by Bill Cunningham, but it was the first time he stopped me and told me to pose. I was wearing this Margiela comforter coat, and he was like, "Hello, child." The fact that Bill stopped me and had me pose was life!

Bill would look at everybody without judgment, including me. He took my photo right in front of the Bryant Park tents during Fashion Week in 2000. I was one of the very, very, very few fashion editors of color at the shows during that time, and Bill paying attention to me was an affirmation.

I had an early interest in fashion growing up. I developed an odd habit where if I saw a page in a fashion magazine with a garment I liked, I would tear off the head of the model so I could just look at the clothes. I was hyperaware at a young age that they were all white and blonde and white and blonde. As a fashion editor, I remained hyperaware of how white and privileged fashion was, and how the people creating the images we'd see were male.

But I didn't think of Bill as white or male; I didn't think about his sexuality. He was our angel. He was the fairy of street fashion. He saw us kids on the street when everyone else was paying attention to the runway. We dressed for Bill. We'd walk around, going, "Does Bill see me?" We would look for that blue jacket and there was Bill.

Bill was most excited by the "downtown" shows where people would perform fashion—gay communities, trans communities, black communities. You knew that you were onto some shit if he was there, showing up on his little bike. Bill didn't care whether you invited him to your party. But he was the only person you ever wanted at the party.

Being photographed by Bill was a validation of my creativity. All humans want to be validated. We want to be seen and for our voices to be heard, especially when we are on the margins because of our socioeconomic background, ethnicity, or sexuality. Fashion gave some of us a voice, and here was this one person with influence at the *New York Times*

who appreciated what we were doing. Bill would put us on the same page as the socialites or the Met Ball, which is what happened with the photograph he took of me wearing this Margiela coat.

The comforter coat is some old thing now, but I love her. And I call her Marge. I'd procured it at a Margiela sample sale in 1998. The invitation to the sample sale came by messenger to my office at *Vibe*. It was very ceremonious. I thought I had won the lottery. Margiela would combine a "shit's-dark-out-there" with a "let's-be-practical" feeling, using very familiar things like a T-shirt, sweatpants, sweatshirt, or a comforter off your bed, and make it fashion. He'd take something that you saw every day and make it ironic in an intelligent way. Margiela's fashion, and especially this coat, supported my politics and my social lens. I was in heaven. And getting photographed by Bill while wearing it? I was giddy.

—AS TOLD TO EMILY SPIVACK

Michaela Angela Davis is a cultural critic, activist, writer, and former fashion editor and stylist. She has lived in New York since 1982.

MIKE
MASSIMINO

During the Space Shuttle program, astronauts were allowed to bring only one shirt for each day they would be in space. As a result, picking out "space shirts" became a much anticipated ritual before a flight. We would pore over NASA-approved Lands' End and L.L. Bean catalogs, picking out colors, styles, and monogramming. These shirts would stay with us forever, after all, as flown memories of our mission. For monogramming, we would pick the color and font and then decide whether to add our mission number or title (e.g., STS-125, meaning Space Transportation System flight number 125) or the name of our space shuttle (e.g., *Atlantis*). The crew, in a display of crew unity, would then pick one shirt for us all.

The rules of shirt ordering were strict; we were representing our country up there. No images or words that could be interpreted as inappropriate could be worn or photographed in space. The rules also existed to prevent an inadvertent endorsement through a commercial logo. Picking out these shirts—while not as important as emergency training or other preflight requirements—was a tradition that made you feel like you were a real astronaut. Only astronauts assigned to space flights got to do this. But it also lacked individualism, as you could not bring a favorite shirt from home to represent just you.

NASA altered the rules, however, toward the end of the Space Shuttle program, allowing astronauts to bring one shirt of their choice. It could be a shirt from a school, sports team, restaurant, branch of the military—just about anything. But you could choose only one. Think about that for a moment. If you could bring only one shirt into space from your drawer at home, which one would you choose? I thought about this for a few days. Should it be my Mets T-shirt, a shirt from my high school, or a U2 or Radiohead concert T-shirt? I finally decided that I wanted to acknowledge the experience that contributed most to fulfilling my childhood dream of flying in space—my college education at Columbia University.

Although my hometown, Franklin Square, Long Island, is only twenty-two miles from Columbia, in Manhattan, it was a world away for me. My parents never went to college, so walking onto Columbia's campus was like setting foot on another planet. It was different from anywhere I had ever been—it felt like this was a place where people came to learn and change the world. Here, I thought, I could be on a road toward achieving any dream, even one like flying in space. Though I first wanted to be an astronaut after seeing Neil Armstrong walk on the moon, I was not thinking about becoming one when I started my education at Columbia. It seemed impossible. But college opens up opportunity, and by the time I graduated, I had realized anything was possible. It might not be probable, but it was possible.

Mike Massimino, a former NASA astronaut, is a professor of mechanical engineering at Columbia University, the author of the *New York Times* bestseller *Spaceman: An Astronaut's Unlikely Journey to Unlock the Secrets of the Universe*, and an advisor at the Intrepid Sea, Air & Space Museum in New York City. He is a native New Yorker.

MIRAH
ZEITLYN

When I go running, I don't wear my nice underwear. I wear my worn-out, period-stained underwear because I'm going to wear it for less than an hour and then put it in the laundry basket. That was the case on August 16, 2015, when I went running in Prospect Park.

I was training for my second marathon. I'd run the Portland Marathon when I was thirty, and forty seemed like a good age to run another. Part of running a marathon came from wanting to deepen my relationship with New York City. I'd moved to Brooklyn less than two years before, at thirty-eight. It was a weird age to move to New York. I remember the empowering feeling of claiming the streets physically in Portland, running from one point to another, with nothing but the power of my own body along with some water and calories. I wanted to claim New York that same way so I could feel more at home.

I was running ten miles that day. I had a mile left of my run and I was feeling great. I was wearing little running shorts and a mesh running shirt. I was on Ocean Avenue approaching Caton Avenue when I saw a couple ahead of me with a dog. I ran by them and all of a sudden this force struck me from behind and pushed me. It was like someone had shoved me hard or hit me with a sack of flour. There was velocity and it hurt. I screamed. It was over in a millisecond. I couldn't understand what had just happened.

The two people with the dog I'd run by looked just as shocked as I felt. Even though it was on a leash, their enormous German Shepherd had bitten me. I lifted the elastic on my shorts and my skin was torn and bloody at the top of my right butt cheek where I'd been bitten.

The man immediately walked the dog away from me and the woman asked, "Do you want me to get you something to clean the wound? Do you want to come up to our apartment? It's right there," and she pointed to the corner of Ocean and Caton. At first I thought I'd keep running home, because my impulse was that I needed to get home as

quickly as possible. I think I was in shock. Somewhere in the back of my mind, I thought, "Animal bite . . . bacteria . . . I should get this cleaned so the wound doesn't fester."

I followed the woman into their apartment building and upstairs. I remember saying, "Fuck, fuck, fuck," which is unlike me because I don't curse much. As I walked up the steps, I was thinking, "Why is my underwear all bunchy?" I saw it was hanging down below one side of my teeny shorts. When the dog bit me, it had not only ripped a hole in the underwear but also ripped the side seam. The underwear was attached on only one leg. I tugged at it and off it came.

There I was standing in these strangers' apartment, clenching my dog-bitten underwear in one hand and pulling down my shorts with the other so they could dab Betadine ointment on my ass.

I asked them about the dog, who I found out was named Wally, and who, by that point, was in a dog crate in their apartment. Was he up-to-date on his shots? Did he have rabies? Had he bitten anyone before? Wally's parents were totally accommodating. The dog was up on its shots, it hadn't had rabies, and this was the first time it had attacked someone.

I kept in touch with the couple for a little while as I was healing, seeing doctors, and getting acupuncture, because they had agreed to cover my medical expenses. A few weeks into our e-mail exchange, the woman wrote that she hadn't been sure how to bring it up but that she and her partner had been listening to my music for fifteen years, and, in fact, they had fallen in love listening to my first record. I'm no superstar, but I am a public person who has been making music and touring for twenty years. I'd had an inkling that they recognized me, that they might be fans. I just sensed it. She said that, in a weird way, Wally might have known and been trying to get them to meet me.

I successfully completed the marathon, but the irony of the dog-bite incident wasn't lost on me. I had wanted to run the New York City Marathon to strengthen my bond with New York, so I could feel more a part of the city. In doing that, I got attacked by a random animal and was left with a dog-tooth–shaped scar on my butt.

I kept the underwear. I know it might seem strange to have sentimental attachment to dog-bitten, ripped-in-half undies, but it didn't occur to me to throw them out. I washed them and put them in a special drawer. If there was a trophy to come out of completing the marathon, aside from my medal, it's this ripped underwear.

—AS TOLD TO EMILY SPIVACK

Mirah Zeitlyn is a musician and songwriter. She has lived in Brooklyn since 2012.

NICK
HARAMIS

Growing up in Cornwall, a small paper-mill town in central Canada, I felt lonely in my ambitions. So I kept them mostly to myself, escaping into a more vivid fantasy world through books and movies. And magazines. In these pages especially, I found my people: freaks whose weirdness was art and whose art was a thing to celebrate. During my freshman year of high school, I was gangly. I wore braces and thick glasses, and my face was muddy with freckles. I sang in the choir because a high-bar accident cut short my gymnastics career. (I was very not heterosexual.) And yet, despite all this, I befriended the coolest girl in school: Michale.

Michale was two years older than me, and she knew so much more about the world. She was a model, and when we met she'd just returned from Tokyo, where, among other things, she'd kissed a girl. She took me out for oysters and to cigar bars, and sometimes we'd stay at hotels pretending to be newlyweds on our honeymoon. She was beautiful and tall and blonde, and I was in love with her. She took me to the prom when no one else would, and she was the one in whom I confided about my plans for the future: living a New York City life as the editor of a magazine. Although others suggested I consider a more likely alternative, she was never once skeptical of the idea. She didn't even seem that impressed by it, which made any dream I had feel somehow more attainable.

In June 2007, the morning after my college graduation, my dad drove me to New York, where I'd taken a summer internship at a fashion magazine. My first week in the city, I went to a party for our rival magazine, *Nylon,* at Irving Plaza. I'd gone alone, and I spent the night pretending I wasn't staring at Blake Lively. I tried to sleep with the DJ that night, or maybe I even did. The next afternoon, I was eating lunch on a patio in Soho when the actor Simon Baker, from *The Devil Wears Prada*, walked by. I guess he'd been at the party the night before, because when he saw that I was wearing the T-shirt that came in the gift bag, he said, "Fun night, right?" Or at least that's how I remember it; maybe he

was just letting me know how hungover I looked. It didn't matter—in that moment I was just so in love with the city, dizzy with the idea of who I could become here.

Two years and one month later, Michale died. She'd been battling anorexia for years, and it finally let her go. She was living in the hospital the last time I saw her, radiant and yet frail in a way that I can only describe as hollow. We were looking at magazines. I remember leafing through the pages, wondering to myself whether she thought the famous people in the pictures—Nicole Richie and Keira Knightley at their most willowy—were pretty, if they looked good. I never found out. Now I find myself struggling to remember if we hugged good-bye.

I was at home in Brooklyn when Naomi, Michale's older sister, called to tell me the news. I was wearing the *Nylon* shirt. I'd kept it to remind me of my first taste of a New York night. But since Michale's death, it reminds me of her. And even though it's now a decade old, stained, and tattered, having long outlasted all other T-shirts, it sticks around.

Nick Haramis is the editor in chief of *Interview* magazine. He moved to New York in 2007.

NILE
RODGERS

I wore this hat when my band, New York City, went on tour with Michael Jackson and the Jackson 5 in 1973. At the time, we had only one hit, but it was enough for us to go on tour with Michael.

During the tour, Michael and I became very friendly because he liked my hippie fashion sense. We were living in an R&B world where most bands had uniforms, but I was a nonconformist. I was also the opposite of Michael's father, Joe Jackson, who was a taskmaster. Michael loved that my mere presence would upset the apple cart. On tour, I used to read to him from San Francisco headshop comic books, pretty hardcore R. Crumb-type stuff. His father would have flipped had he known what I was doing. I would put the comic books inside faux covers of *Archie*, *Jughead*, *Veronica*, or *Richie Rich*—the most innocent, Americana, white-picket-fence comic books.

I had all my custom hats, including this one, made at Jay Lord Hatters on West Thirty-Ninth Street. Over the years, I bought dozens of hats from them. In the black community at that time in New York, everybody was wearing applejacks, Kangols, and super-wide-brimmed pimp hats. I'd go into Jay Lord and say, "What's the coolest new stuff? What are you guys doing now?" Because they mostly made more straightforward styles for businessmen, they would be excited to make hats for me, especially like this one, a classic fedora mixed with the wide-brim pimpy style.

The *Superfly* look was big. Black people dressed in that style. I didn't dress like that because it was a different cultural thing than the hippie thing I was into. I never shopped at Mr. Tony's on 125th Street in the 'hood, which sold bespoke, custom-made clothing, although places like that were flourishing. Instead, I shopped at Limbo in the East Village or Charivari on Fifty-Seventh Street. I'd go to Skin Clothes because if you didn't shop at Skin Clothes, you weren't a real rock star. Or Ian's, where I'd buy Loons—super-tight, flat-front pants that, if you were well endowed, would accentuate your penis.

I wanted to stand out from the crowd and, as Jimi Hendrix would say, wave my freak flag high. But I wanted to be part of a community, too. Even if my bell-bottoms were Landlubber hip-huggers or my shoes were platforms, once I wore a hat, people would think I was all right. As a professional musician, I had to be malleable because I gigged in all types of places. One day we'd be opening for the Jackson 5, another day we'd have a gig at a nudist colony, and the next day we'd be performing for the mob. My hat was a leveler. It made me more acceptable to the R&B and funk communities. My motto was, "If you want to get ahead, get a hat."

—AS TOLD TO EMILY SPIVACK

Nile Rodgers is a record producer, songwriter, musician, composer, and guitarist for the band Chic. He is a native New Yorker.

PATRICIA
BATH

I met Martin Luther King Jr. in 1964. I was in Alpha Kappa Alpha as an undergraduate at Hunter College, and as a member of the sorority I helped organize civil rights demonstrations. I became the sorority's national vice president, and we held a meeting where it was my honor and job to introduce Dr. King. I had an opportunity to chat with him, and it took only that one meeting for me to become a disciple. I was totally hooked. His charisma, his brilliance, and his intelligence were palpable. I wanted to help his narrative of marching forward.

I went to medical school at Howard and had planned to do my internship at the Hôpital Saint-Louis. I even had my acceptance letter. But after Dr. King was assassinated, I had to say no to the idea of simply having fun in Paris. I had that fiery passion and energy of being in my twenties. I had to concentrate on helping with the struggle and contributing to society.

I decided to do my internship at Harlem Hospital, to go back to the community where I'd grown up. But first, to honor one of Dr. King's dreams, I spent the summer after medical school in Washington, DC, working with the Poor People's Campaign, providing health services to people who were living in Resurrection City. When I got to Harlem Hospital, I saw my work there as a continuation of service to humanity.

I put on this jacket for the first time on July 1, 1968, when my internship began. It was the protocol for interns to wear a short white jacket. I knew I looked sharp, with my teeny skirt, my pearls, and my heels! The year I began my internship was also the year that Columbia University broke from its Ivory Tower tradition and decided to send its medical school graduates to Harlem Hospital. This was part of a movement to eliminate the notion that we should have two different classes of medical care. As a graduate of Howard, I worked alongside interns, faculty, and students from Columbia. What you saw happening at

Woodstock and at those famous events where people came together as one—that like-mindedness—was also happening at Harlem Hospital. It was electrifying and fantastic.

There was a revolutionary spirit about every single thing we were doing—even, for example, our decision to have a party every Friday. Why? Well, heck, everyone was working all these crazy hours, forty-eight hours at a time, and nobody had time for friends or family outside of the group. It was like a boot camp medical experience. So we started something called "liver rounds" as a joke. When you're a physician in a hospital, you do rounds all the time—morning rounds, evening rounds—to check on patients. We called it "liver rounds," because if you drink too much alcohol, your liver will go. We would have disco music, alcohol, and dancing in the physicians' lounge. It was amazing.

At that time I also made an observation that led me to specialize in ophthalmology. I was surprised to find so many people who were blind at Harlem Hospital's eye clinic. And this finding was in stark contrast to my experience downtown at the clinic at Columbia. The rate of blindness among black people was double that of white people. Blindness due to glaucoma was eight times as frequent among black populations as white populations. And it could be prevented with access to medical care, early diagnosis, and detection. Seeing that led me to my research on blindness and to one of my first discoveries.

Based on my civil rights background, I saw this as an instance of health care inequality, and not only in the narrow context of service for black people. Rather, I saw it universally, because equality and mutual respect are deserved by everyone. Gay people, transgender people, people who are disabled, and people dealing with issues around gender pay disparity or health care disparity have all benefited from the work of Martin Luther King Jr. Dr. King changed my approach to my work.

As for gender inequality, you have only to look at class photos of medical school graduations in the 1960s to see how few women were in the field. But it's all been changing. My daughter is a physician, and I hope the legacy will continue with my granddaughter, who's in second grade. She and I do pretend play. It's what kids do these days. They pretend to be a police officer, Elsa from *Frozen*, Superwoman, but I know she and I will play doctor with this old jacket.

—AS TOLD TO EMILY SPIVACK

Dr. Patricia Bath is an ophthalmologist, academic, founder of the American Institute for the Prevention of Blindness, and inventor who holds five patents for treating cataracts. She was born in New York and lives in Los Angeles.

PATRICIA
TALISSE

I came to New York from Aleppo, Syria, for two months in 2012. I'd come for a summer stay and to do a little shopping. I'd done that before. I thought, "It's only two months." I would go back when the war was over. The clothes I bought were dressier, stuff I would wear only in Syria—dresses and high heels. I think I was in denial about the war, pretending it wasn't happening in my hometown. I still have the items I bought but never wore. I hate them. It's like, "What was I thinking when I bought these?"

I was staying with my brother, an architect who had been here for eight years. I extended my stay for two more months, and then extended my ticket again. Eventually, New Year's came and the war was still going on, so I cancelled my return ticket. People would tell me, "Don't go back. It's awful." I would see pictures of my neighborhood and the places where I used to go—they were destroyed.

Because I assumed I was returning, I left my Girl Scout uniform, including this neckerchief, in my bedroom in Aleppo. I'd been in the Girl Scouts in Syria from age seven until the day I left for New York. It's where I learned to have self-confidence and courage and to face my fears. When I came to this country and to New York, I had a lot of fear— a lack of knowledge about available resources, inadequate understanding of United States customs and institutions, and a language barrier. Not speaking the language was not an easy thing. When I wanted to pay for something and the salesclerk said, "Debit or credit?" I had to call my brother and ask him what the difference was.

I tried to join the Girl Scouts here, but I had a hard time. I started applying for jobs. I have a psychology degree, which was valued in my country. I had a whole community, a neighborhood, and the Girl Scouts. Here I was a nobody, a ghost, just a Social Security number. When I applied for jobs, I got the sense that people would not even look at my résumé, that it would go into the garbage.

I worked at Blimpie, I babysat, I worked in a warehouse, I worked in retail. For the retail job, I walked into a store and asked if they were hiring. I learned a couple of sentences in English, I spoke them, and the manager hired me. I used to pray every time I went to work, because I was afraid I wouldn't be able to speak to customers.

I thought that I probably needed a prestigious school on my résumé and that I should get a master's degree. I said to myself, "Let me do something while I'm in the United States. I don't want to go back to Syria with nothing." I learned about something called social work, which we didn't have in Syria. I realized it had similarities to being a Girl Scout and wanting to make the world a better place. I applied to Fordham for that program and I got in.

I planned to finish my master's and return to Syria. While I was in school, though, I realized that the war was not going to end soon, that it had more power than us. The survivor's guilt killed me. I used to cry on the subway. I didn't know why. Maybe because I would learn about what was happening in my own neighborhood, receiving WhatsApp messages about who survived and who didn't. I tried to shift my focus to my master's degree, to working with New Yorkers, but you cannot disconnect yourself from your past.

I'm different than I was in Syria. I used to have more confidence. I used to have a louder voice, as we say. But here, you get used to feeling that you are lower as a person. At the same time, I know I've achieved a lot. I receive messages from the girls I used to lead in the Scouts. They say, "You're still my role model." Or, "No, Patricia, you're not a weak person, you can do this. Remember who you are and nobody can fool you." That gives me courage. The Scouts' motto, *Guide Toujours; Prêt*, is a reminder to not be afraid of anything—or maybe, to be afraid but to have courage.

My father had been going back and forth between New York and Syria, because there was business he couldn't handle from here. One time he went back to our home. It's still there. The windows are all broken from the bombing, but my bedroom is still intact. I asked him to bring back my Girl Scouts neckerchief. It was the thing I wanted the most from my room. I used to wear it all the time with pride and confidence. But now I just want it here with me, even if I'm not going to wear it anymore.

—AS TOLD TO EMILY SPIVACK

Patricia Talisse recently graduated with a master's degree in social work from Fordham University. She grew up in Aleppo, Syria, and has lived in New York and New Jersey since 2012.

PEE WEE
KIRKLAND

This jacket would exist in a person's life only if they were either very wealthy or very stupid. I was younger, about sixteen or seventeen, so I guess I fall into the category of very stupid. At that point in the mid-1970s, buying a jacket for $2,000 seemed like the thing to do. When you have money, you tend to buy things to look different and that other people can't afford.

I kept this jacket, because how do you give away a jacket that cost more than $2,000? I don't think I've worn it more than twice. At that particular time in my life, if you wore a jacket to an event, you couldn't go to another event wearing the same thing. I can smile about it now, but it's hard to believe. I was a kid, but I can't use that as an excuse.

I first got the reputation of being a guy you didn't want to deal with when I was thirteen years old. I was at a party and I told an older guy that he couldn't be disrespectful to a friend's mother. He said, "Do you have a problem with that?" And I said, "Yeah, I have a problem with that." He held a gun at my head. It clicked three times, so loud I thought my head was gone. Everyone saw. That created a reputation on the street that I was crazy. I wasn't crazy. Just not afraid to die.

It was an era in money that Harlem had never seen. An era in the life of crime that New York City hadn't seen. You'd go up Seventh Avenue in front of the Shalimar, the Gold Lounge, and you'd see all these Rolls-Royces, Mercedes, Ferraris, Maseratis, Lamborghinis. I was riding around in all those cars thinking I was happy, but I was happy stupid.

No child was ever born to be a criminal. But waking up in the morning and shaking the cereal box so the roaches go to the bottom, you're thinking, "Man, this is never gonna change." And then there's the illusion of the drug game—that something good will come of it. You're gonna make money. You're gonna have a good life. You're gonna move from Harlem to mansions with elevators in them. The only place you're going to move before it's all over is to whatever prison you get sent to.

I look at this jacket now and it has no value other than motivation for me to continue to make young people understand what real value is. He among us who is better is he who is most dutiful to God. And when we understand that, we understand the consequences of our actions.

After I went away to prison for twelve years, I did more than reinvent myself. I think God helped bring me back from the dead. The illusion of the game? It ain't worth it. Millions of dollars are not worth doing ten or fifteen years in prison, especially when you see how badly your daughter wants her father home for Christmas or her birthday, and how her mother has to make excuses because you're not there. The jacket reminds me—how could you have ever been that stupid? You might have invented stupid to think that this amount of money could make you happy.

Prison for me was a mental solace. Finally, I was free. Free to begin another life. Because once you're in the drug game, once you've committed yourself to the crime game on the level I had—death before dishonor—there's no way out. The only way out is either death or you go to prison and serve your time. When you come out, the choice is yours.

A kid in Brownsville told me, "The thing is, Pee Wee, I can't turn my back on the gang because that's my family. I don't know no other family. I was born in prison." It's easier to stand over someone's back when they're playing chess and say, "Yeah, that's the right move," because the pressure's not on you. But I had been there. I had lived that life. I told him, "You don't have to stay in the drug game to see them as family. You can do the right thing in your life. Because otherwise, the same thing that happened in your mother's life and your father's life is going to happen to you. You're gonna find a young lady. You'll go to jail. She'll go to jail. And when you have a child together, the child is going to prison someday, too." It's a cycle. It don't stop. That kid? He turned his life around. But it's not easy. Because what happens when the mother is in prison and the gang is a kid's first caretaker?

I say to youngsters, "When you look at movies and see kids running around, killing one another, playing gangster like it's a joke? It's not." I tell them, "Real gangsters don't kill each other. If you want to prove you're a gangster, you have to be willing to give your life to save somebody else's life. That's gangster."

I tell them, "You'll listen to me when you're tired of being stuck on stupid."

—AS TOLD TO EMILY SPIVACK

Pee Wee Kirkland is a former street basketball legend and a former gangster who began the Harlem-based School of Skillz basketball and life skills campaign. He is a native New Yorker.

RAY
GOODMAN

My first time on St. Marks was when my mother brought me from Jersey City on the PATH train. We went to see *Man of La Mancha* off-Broadway. I was probably thirteen years old. We got off at Ninth Street and Sixth Avenue and walked east on Eighth Street. At some point, I felt a change. I remember thinking, "I don't know what's going on here. This is insane, and it feels right." That was in 1967. From then on, on weekends I would go to St. Marks with a friend, walk around and take in the poster shops, button stands, and clothing stores, places like the Five Spot, the Electric Circus, and Paul McGregor's hair salon, where the shag haircut was invented.

I started Trash and Vaudeville in 1975 after realizing I probably wasn't going to make it as a drummer in a rock-and-roll band, and psychedelic lighting, which I did for a little while, came and went. I wanted to stay close to rock and roll. From the beginning the store was curated to make sure that whatever we hung on the racks was, as we called it, "rock and roll to wear." Over the next two or three years, the store developed a reputation for having a selection of clothes that appealed to musicians.

The single most iconic thing Trash and Vaudeville has ever made is black jeans. I made my first pair in 1978, after numerous requests from customers and out of my own desire for a tight pair of jeans, which had been impossible to find.

Originally they were made in Brooklyn, under the Williamsburg Bridge, in a little factory owned by two Hasidic Jewish guys. I didn't know much about pants, but I'd say to them, "Can we make the leg opening smaller, like from seventeen inches to fourteen and a half? Can we make the thigh tighter?" I could tell they enjoyed it, too, because it was something different for them. They'd ask, "Who's wearing this? What are you doing with this stuff?" They'd make me about sixty pairs, which you could do in those days, and in two weeks I'd come back. "Really? You sold those?"

Word got out about the black jeans. Mick Jones from the Clash would come in with Joe Strummer and their tour manager Kosmo Vinyl. In *The Clash on Broadway* box set, there's a shot of Mick Jones on a rainy New York day, standing under a lamppost clutching his Trash and Vaudeville bag. Joey Ramone would come into the store with his mom and buy jeans. Slash, of course, got his jeans here. Marky Ramone and Iggy Pop still wear our black jeans. Bruce Springsteen was a big black jeans guy, especially back in those days. Being a Jersey guy and growing up on Springsteen, that was really important to me.

The icing on the cake was that I got to meet so many of these people, to become friends with them. Because I'm basically a groupie at heart. From the beginning, it was all about, how do I stay close to this?

I always loved being on St. Marks, especially when we opened in the 1970s. At that time it was very much a neighborhood. It wasn't unusual to see the same people you worked around during the day out at night, because we all went to see bands at the same clubs. The amazing group of stores, restaurants, and haircutting places on the block, and all the people who ran them, represented a lifestyle.

But I loved it a little less when the block became primarily a food court and bong market. Look, I like bongs as much as the next guy, but do you really need twenty-five stores selling them? I started noticing it in 2010—rents just got too high and people couldn't afford to take a chance. St. Mark's Books is gone, Kim's is gone, Dojo left the block, Sock Man has moved, the shoemaker across the street who put platforms on your sneakers, he's gone. That's why we moved to Seventh Street. I didn't want to feel stagnant. It's more like what St. Marks used to be.

In certain respects, not a lot has changed. And now we're into the third generation of families getting their black jeans from us. Dads will bring in their twelve- and thirteen-year-olds for their first pair. I feel very fortunate. I did this for the love of rock and roll.

—AS TOLD TO EMILY SPIVACK

Ray Goodman is the owner of Trash and Vaudeville, which he opened in 1975. He moved to New York in 1975 and has lived on St. Marks Place for the past twenty-five years.

ROSEANN PALMIERI

When I started working on Wall Street, I was a rare animal. I was a woman in technology on Wall Street. This was in 1989 and I didn't have a lot of female role models. It seemed to me that women had to dress like men, to blend in and not embrace femininity. I'm the exact opposite. I'm a girly girl.

I always knew I would work in the city for an investment bank. That's where I saw myself. While I was at Hofstra University, I went to my first on-campus job interview. I'd read a book beforehand that recommended playing down "beauty" for the interview process. But then I was interviewed by a woman who had on pretty pearls, a cardigan, and a skirt. She looked beautiful. I had short hair, a white, button-down collared shirt, a blazer with shoulder pads, no makeup, no jewelry, no polish. I felt horrible because I didn't feel like myself.

When I go into meetings and I'm representing myself and my company, I like to look the part. I always say dress for the part you want, so if I'm asking for a million bucks, I better look like a million bucks. That's why I always go to a black pencil skirt. I feel confident and comfortable when I wear it, and it works with everything. I did try the pantsuit thing for a while, not gonna lie. It didn't feel as good.

I worked at Deutsche Bank for six years, and we'd have to go to London every couple of months. The old pencil skirt would travel well. You can roll it up, throw it in a suitcase, and when you're on a three- or four-day business trip, you can wear it at least twice. We'd arrive at the London office and between the high heels, the black, and the attitude, they'd say, "The New Yorkers are here again!"

I can talk finance and fashion and be completely comfortable. I can walk out of a meeting about a multimillion-dollar deal and another woman in the room might say, "I love your Jimmy Choo bag." It doesn't define me and it doesn't hold me back. It's part of who I am and I'm comfortable with it.

I assumed that when I got pregnant, I would stop working and stay at home. But, then, when I did get pregnant, to my surprise, I couldn't give up my career. Not after I'd scraped together money to get through college and worked my ass off to pay my own student loans. Plus, I enjoyed being a techie. I wanted to find a way to be a mom and continue working. At that time, I was working at Morgan Stanley, which was the cream of the crop. I couldn't walk away. But I thought, "I will be damned if I am going to wear baggy pants and flats," and I invested in my maternity clothes. I bought maternity pencil skirts and tailored things because that's what I liked to wear to work.

When my daughter was younger, she would watch me get dressed every morning. And if, on the weekend, I would put on makeup or nice clothes, my son would cry because he thought I was going to work. To them, the makeup, the heels, the pencil skirt—that uniform said mommy was going to work.

My interest in fashion came from my nonna. I'm first-generation Italian, and my grandmother, who lived with us for a little while on Long Island, would usually wear a housedress when she was inside. But if we said, "Nonna, we're going to the store to get some milk," she'd come downstairs fully dressed with little heels, a matching pocketbook, and a beautiful cardigan with a fur collar. Just to walk out of the house, she looked a picture. So while I didn't have a business role model, I did have a role model for fashion.

—*AS TOLD TO EMILY SPIVACK*

Roseann Palmieri was an executive at Morgan Stanley, Deutsche Bank, Merrill Lynch, and Bank of America, and is currently the CEO of a fintech startup, DEXTR. She lives on Long Island with her children and husband.

RUTH
FINLEY

The idea came to me pretty easily. One family friend was working for *Mademoiselle* and another was a syndicated fashion writer. They were complaining that they'd both received invitations to fashion shows happening at Bergdorf's and Saks Fifth Avenue at the same time. How were they supposed to go to both? That's when, in 1940, I first came up with the Fashion Calendar concept.

I started it a year later. My very first office was in my apartment on Fifty-Second Street right across from the 21 Club. I hired my roommate to be my secretary. She was a very good typist and didn't have a job, so for six or seven years we lived and worked together. We paid fifty-five dollars a month for a three-story walk-up that had bedbugs. We didn't make any money at the beginning. To earn enough for food and rent, we worked at a theater at night, the two of us, seating people, which they don't do anymore.

When I started my business I looked like I was fifteen years old, even though I was about twenty-five. I scheduled shows by phone because I looked so young, but I was telling people what to do and they were taking my advice. For about six months I had been speaking to one man who headed up the Fifth Avenue Association, and eventually he said, "Come down to the office. I would like to meet you personally." When I arrived, he looked at me and said, "You're not Ruth Finley!" He had envisioned an older person, wearing glasses, very serious. He shook his head. He couldn't believe it.

In those days, people always wore hats. I never walked out of the office without one, especially because I thought that wearing one made me look older. In the fashion world of the late 1940s and into the 1950s, there were two big millinery weeks in New York City per year—in January and July. During those two weeks, I tried to wear each designer's hat to his or her show. If it was a Sally Victor show, I'd wear a Sally Victor hat. If it was a John Fredericks show, I'd wear one of his hats. This is one of the winter hats I wore to

the shows. I've kept it because I've continued wearing it ever since. Recently I went to a fashion event and wore a hat—I was the only person there wearing one.

Back in the 1940s and 1950s, designer names weren't huge. A designer wouldn't put on a fashion show. Instead, department stores like Bonwit Teller, Wanamaker's, Lord & Taylor, or smaller boutiques would do them, and it was usually for charity. It was because of World War II that New York evolved into something important in the fashion world. Paris couldn't do much because they had no fabric, and after the war, they had only couture. But New York did ready-to-wear, and that's what helped the city become so successful.

When I got married, I moved to Long Island. I lived there for four years and hated it. I kept working on the calendar and commuted into the city a couple days each week. Eventually I got divorced and came back to the city. By 1955, I had married a wonderful person. I had three kids and we lived in a townhouse on Seventy-Seventh Street. My office was there, too—it had its own entrance. I could have lunch with my kids after elementary school and still run the business.

By then I would receive as many as 150 phone calls each day. We never had an answering machine in my office—usually there were a total of three of us answering phones. When I was scheduling shows, I would make sure that no two were at the same time. And I would keep them geographically organized, so that people wouldn't have to travel great distances.

One person who called at the beginning of her career was Diane von Furstenberg. She took her designs to *Vogue* when she arrived in New York. Diana Vreeland, the editor in chief, said, "Oh, these are beautiful," and then left the room. Diane said to Vreeland's secretary, "What do I do now? She loved the clothes but didn't give me advice." The secretary said, "Call Ruth Finley." Right from the beginning Diane called me. This was in the early 1970s. I suggested that she invite editors to a hotel where she could show them the clothes. That's how she got going—even today she tells that story. It happened a lot— when designers wouldn't know what to do, someone would say, "Call Ruth Finley."

—AS TOLD TO EMILY SPIVACK

Ruth Finley is the founder of the Fashion Calendar and a central figure in the American fashion industry. She has lived in New York since 1945.

SHOHAM
ARAD

It was NYU graduation weekend and the East Village was mobbed. My cousin Liandra had just graduated from medical school, so I took her to my favorite restaurant, il Buco, to celebrate. The restaurant was packed. They sat us at the bar. I checked my coat. I'd just bought it at the Rachel Comey sample sale and I loved it. After I checked it, I realized I'd left my brand-new iPhone in the pocket. Initially I thought, "I should go grab it." But then I decided, "You know what? I'm going to be really present for this dinner."

We had a great time, like we always do. Around midnight, when we were wrapping up, I gave the hostess my coat check ticket. Liandra and I talked for another twenty minutes. It was taking a while. Someone from the restaurant came up to me and I said, "You lost my coat." She nodded. "No, no, I was joking, you definitely did *not* lose my coat!" She told me that in twenty-one years, this had never happened.

There had been a huge party at il Buco that night, she told me, and they'd given my coat to someone at that party. "Whose party was it? Can you just call them? What moves have you made? Where's my coat??"

Liandra realized, "Wait, if your phone is in your coat pocket, we can track your phone! We're going to find it. Let's go right now!" We looked on her phone. We were on Bond and Bowery and the map showed my phone was at Thirteenth and University. We fought off drunk people and got into a cab. We went to this random bar and walked through, scanning every single person to see if they had my coat. We saw that a big party had just left and the bartender told us we just missed them.

We rechecked the tracking app. It looked like my phone and whoever had it was around the corner on Twelfth Street. It was totally residential; there wasn't even a bodega. No one was out. Liandra stood in the street screaming, "You have my phone! You have my phone!" and I knew we were those fucking people in the middle of the night I complain about all the time who are just yelling shit up at apartments. We figured out what building

my phone was in. We called il Buco. We told them we'd tracked the phone and coat to a specific apartment building. What was the name of the party? The hostess had only the first three letters of the name on the reservation: G-I-L. We scanned through the building's directory and there's a Gilman. That was our guy! We started buzzing, and at this point it was one in the morning. We were laying on the doorbell like assholes, thinking we're probably buzzing a sweet old couple in the middle of the night.

All of the sudden, the buzzer opened the front door. We rushed inside. But now we were stuck in the three-foot space between the front door and the foyer door. Dear Gilman, do you think that after buzzing you for fifteen minutes, we're not going to bother you anymore? We started buzzing again. After ten minutes, the door opened! We were so hyped up at this point, standing inside a random apartment building.

OK. Gilman. 3C. We got off the elevator at the third floor and it was perfectly quiet. "Oh God, maybe this is a terrible idea," I thought. But at the end of the hallway, this bro opened the door. He was twenty-two or twenty-three. We walked toward him. "Heyyyyyyy," he said, and we responded, "Where's the phone? Where's the fucking phone?" I could see my coat behind him. He replied, "Oh my Godddddd." He was so high. You could smell weed wafting out of his apartment. He was holding my phone like it was a gift, like I was going to give him gold stars for having it. He started telling me how someone named Rachel wasn't feeling well and was in bed and told him that he should answer the phone because it kept ringing and also to answer the door because it kept buzzing.

I didn't care who Rachel was. I just wanted my coat. I was trying to get behind him to get it. He finally handed me my phone and my coat. Then he put his hands on my shoulders. "Do you want to come in? You girls look hella hot." "Fuck you! Absolutely not." We took my coat and headed back to the elevator, laughing. Before we got on the elevator, the last thing we said to him was, "Namaste."

—AS TOLD TO EMILY SPIVACK

Shoham Arad is the deputy director of the TED Fellows program and an industrial designer. She has lived in New York since 2011.

TAUNO
BILTSTED

By the time I was eighteen or nineteen, I was part of New York's DIY culture. I was a punk, but I wasn't into the macho hardcore bands that were big in New York at the time, like Cro-Mags or skinhead-type punk. The music part wasn't what interested me. I was drawn to people getting together and doing things themselves, relying on each other, and being willing to be rebellious.

There was a big movement of people taking over abandoned buildings in the East Village and making their own spaces. In 1989, I moved into a place called C-Squat, which was on Avenue C between Ninth and Tenth Streets. The building was a disaster. The back half was filled with rubble. The roof was caving in and leaking. We had no heat. We had very limited electrical power. And we kept the windows blacked out so the building appeared to be vacant while we lived there and worked on fixing it up. It had a pretty apocalyptic feel. Most people who lived there were traveling punks, but there were also a bunch of Hungarians who had fled communist rule, artists, and drifters.

That's where I met my friend Paul. Paul was a red-headed kid from New Orleans. He was a good friend of the woman with whom I later had my daughter. He became my roommate in my tiny top-floor apartment at C-Squat.

Paul was a bright and interesting character—a little bit mad but lovely, sweet, and generous. He was a bike messenger who liked dead things. He had a septum piercing and wore a little cat bone in his nose. He liked working with bones and leather, and one day he gave me a belt he'd made for me. At the time, I guess I was like, "Oh, thank you. It's nice."

After a couple of years living at C-Squat, I decided to give my apartment to Paul and travel in Europe. A week or two after I left, Paul, who was an occasional drug user, OD'd and died. It was really upsetting, both to lose a friend and to feel somehow responsible, like I'd had some stabilizing influence on his life, but then I left.

When I returned to New York, I didn't want to live in C-Squat—not because of the memory of Paul but because I wanted to be somewhere more stable. I moved into a squat called Umbrella House on Avenue C between Second and Third Street. In contrast to C-Squat, the people at Umbrella House were more focused on fixing up the building than on the social scene. In between driving a taxi and going to college, I threw myself into the building. We pooled our money and ran new electrical services up to all eighteen units in the six-story building. We got new plumbing. We did it ourselves, all up to code and under the supervision of professionals. The conditions got better and better all the time.

I stuck it out and it's where I live today, more than twenty years later. Now we're a Housing Development Fund Corporation co-op. We have a beautiful, 1,000-square-foot roof garden, which we developed ourselves to grow vegetables for people in the building. We have a community space where people have art shows and performances. We're financially healthy. We have meetings to discuss how to improve the building, where the decision-making is horizontal and shared by everyone. It's pretty idyllic.

And for more than two decades, I've held on to the belt Paul made for me. For ten years, it was the only belt I wore. After getting it repaired a few times, the leather couldn't be fixed anymore so I got new leather for the buckle, but held on to the original leather he gave me. Over the years, it's made me think about my connection to Paul and to that wild and free moment when we were living in C-Squat and feeling really open, like anything was possible. However hairy the circumstances at C-Squat were, we felt like we were living in a new world being built on the ashes of the existing world. It felt dramatic and big. Incidentally, the building is still there, and now it's legal, which is pretty wonderful.

I've gone through ups and downs in terms of feeling defeated by the East Village's gentrification, but for a gentrified neighborhood, it still feels like something has been preserved. People fought hard for protections so that we can live here today. Nobody got everything they wanted, but they got something. And cumulatively, that's meant that there are more units of housing for weirdos, poor people, crazy people, and alternative people than in other gentrified neighborhoods in New York.

—AS TOLD TO EMILY SPIVACK

Tauno Biltsted has been a cab driver, flower arranger, social worker, roustabout construction worker, novelist, mediator, squatter on the Lower East Side, parent of a college student, and gardener, and is currently working on finishing a collection of short stories when not remodeling bathrooms. He has lived in New York since 1985.

THELMA
GOLDEN

In July 2006, I was invited to a party at the Top of the Rock by my dear friend Kim Hastreiter, the founder and editor of *PAPER* magazine. As soon as I got there, Kim introduced me to her friend, the designer Duro Olowu. I said, "I'm so thrilled and pleased to meet you." I went on to tell him in an effusive manner what a fan I was of his fashion and his work, how it spoke to some of the very same qualities that I found compelling about the artists I've been privileged to work with in my career, and how much synergy I found in the way he approached inspiration and concept. And being a New York woman, I couldn't not mention that I'd been on a boutique's waiting list for a dress of his that had been featured in *Vogue*. But then I had to get to an opening, so I left.

Through a set of circumstances in the coming weeks, Kim made it possible for Duro to get my phone number and for us to be in touch again. Very shortly after, in the fall of 2006, we began seeing each other. From then on, I have been very lucky to live my life in his clothes.

In the spring of 2007, Duro and I were invited to an überfancy dinner at the Four Seasons. For the first time, he said, "I will make you something." It felt like the greatest gift he could give me. This dress was inspired by the geometry and architecture of Mali, a place where Duro finds constant inspiration. The dress also echoed Josephine Baker and how she was such an embodiment of the Jazz Age and the way African culture informed how she saw the power of her beauty, the power of her dance—the hybridity that informed so much of what is important about postmodern culture. It's made of vintage couture fabrics, so there's a little bit of Abraham, a Swiss fabric company, Gandini from Italy, some 1920s French gold thread ribbon, and then fabric Duro designed. I see Duro as a collagist and this dress is a collage. As a two-dimensional object, it feels like a work of art. As a three-dimensional object, I get a chance to wear a work of art. That's what it feels like putting it on.

Later that year, Duro asked me to marry him. I said yes. We planned to get married at the Marriage Bureau in City Hall. I said very simply to Duro, "I want to wear that dress." On January 2, 2008, we went to the Marriage Bureau.

I loved getting married there. I am a born-and-bred New Yorker and the child of born-and-bred New Yorkers. My father was born in 1926 in Harlem. My mother was born in 1930 in Bed-Stuy, Brooklyn. My entire life has been in the city. The experience of getting married at the Marriage Bureau was one that resonated with every other New York experience I've ever had. In front of us in line was a couple who were doing it on their way to work. Behind us was a young woman in a full wedding dress with her soon-to-be-husband in uniform who was clearly about to be deployed. They had so many relatives with them. I could have stood there all day watching everyone else get married. I was fascinated by the range of humanity, experience, and what it meant for everyone in those seven minutes or so—and that we were all there together in this very essential ceremony.

The room we got married in looked a bit like a courtroom. You needed a witness, so we asked Kim Hastreiter. Glenn Ligon, an artist who is deeply important to me and who is a brother and friend, was there with us as well. You go inside the room in groups, you sit and wait, and then you're called in the order of your marriage license. It's first come, first served. They call your name, you stand, they do the ceremony and say all the legal words, and you say, "I do." You move on and the next couple comes up. It was without any fanfare. The woman who married us was a city clerk who clearly loved her job and gave it as much as if we'd been married in a cathedral. When she finished with us, she went on to the next couple. Just hearing all the names called out felt like an incredibly New York experience—looking at all the multicultural combinations of people, all the ways we understand family, how everyone came with some version of their tribe.

We had gotten a car service to take us to City Hall and we'd asked our driver to wait. He must have ascertained, based on our conversation in the car, that we were going to get married. While we were in there, he went to the corner bodega and bought me a bouquet of roses, which he gave me when we returned to the car. It was so completely wonderful.

I've worn this dress many times since then. When I wear it, people say, "That's a great dress," and I respond, "I wore it to my wedding." The dress lives on as the way I think about that day we got married. But I love that it's not away in a garment bag, that it exists within the context of my life almost ten years later.

—AS TOLD TO EMILY SPIVACK

Thelma Golden is the director and chief curator of The Studio Museum in Harlem. She is a native New Yorker who was born and raised in Queens.

TIMOTHY GREENFIELD-SANDERS

In 1985, Rei Kawakubo of Comme des Garçons asked me to photograph artists wearing her new menswear line. When the collection arrived from Japan, I started setting up shoots at my studio in the rectory where I lived on East Second Street. I persuaded Robert Rauschenberg to sit for a portrait. The night before, we happened to be at the same party and he was completely wasted. I was horrified because I thought he wasn't going to show up for our 10 A.M. session the next morning. As I left, he slurred, "I'll see you tomorrow." And at 10 A.M., he was at my studio, all ready and coffee'd up. We had a fabulous shoot. I persuaded Leo Castelli, David Salle, and Robert Pincus-Witten to pose for my eleven-by-fourteen view camera. I shot a handful of black-and-white images of each subject. Sitters got an honorarium and the clothing they wore.

Leftovers went into my closet, like this little black shirt that arrived one glorious day in one of the Comme des Garçons quarterly shipments. There was a white version and a black version. (Andy Warhol was set to model the white one but died three days before the shoot. Ross Bleckner took his place.) I still remember trying on the black one and immediately thinking it was a masterwork. It had flawlessly cut short sleeves and lovely black buttons and was constructed from the softest, deep-black linen on earth.

Over the next four years, James Rosenquist, Julian Schnabel, Joop Sanders, Mike and Doug Starn, Peter Halley, Chuck Close, and Francesco Clemente, among others, all sat for portraits. Willem de Kooning, while I shot him, was moving his fingers around on a little dusty table in my studio. When the shoot was over, I noticed a perfect de Kooning in the dust.

There was no stylist—I didn't know what a stylist was—and these weren't fashion portraits, but the fashion world started to take notice. Despite the small print run, publicist Marion Greenberg made sure that the images landed on all the right desks.

Season after season followed, and posing for this series became something coveted in the art world. It was like having a cameo on the TV show *Batman*, which everyone in

Hollywood clawed after at the time. But this was cool, not camp. Eventually, thanks to Rei and the Comme des Garçons campaign, fashion editors reached out to me with "fashion portrait" work, and even Barneys New York hired me to shoot movie stars for an entire year.

Over the years, I wore this shirt to death, really to the point that it was getting a little WASPy eccentric-looking—that ragged-edged, frayed-collar look that only stylish rich people can get away with. Thirty years later, this shirt still gets pulled from my closet for all the right occasions.

Rei, let me say, "Thank you."

Timothy Greenfield-Sanders is a filmmaker and portrait photographer whose photographs are in the collection of The Museum of Modern Art. He has lived in New York since 1970.

TREN'NESS
WOODS-BLACK

My grandmother Sylvia sent me this dress. I mean she sent it to me from heaven. She passed on July 19, 2012, and I helped plan a big funeral for her in New York the following week. All the planning was absolutely crazy. I didn't have a lot of time to shop for what I was going to wear, and for African Americans from the South, clothing plays a big part in funerals. I went into Fox's, a boutique I always go to in Eastchester, and no lie, I said, "Grandma, I don't have a lot of time. You've got to send me something." Three steps into the store I saw this Byron Lars dress. It made me feel like I needed to put on a fascinator and some Mary Janes, like I needed to go to the Cotton Club or the Savoy and shimmy. It looked so Harlem Renaissance, so retro, so angelic.

My grandmother had one of the most amazing going-home celebrations. She lay in state at our family's church, Abyssinian Baptist Church, for an entire day. The street was blocked off in front of the church. News crews were everywhere. A police escort took us from her house in Mount Vernon to the church in Harlem. President Clinton, Mayor Bloomberg, Mayor Dinkins, and Reverend Al Sharpton spoke at the funeral. Thousands of people paid their respects. I was coordinating the day's events the whole time, even texting in church, thinking, "Forgive me, Lord."

After the funeral, the hearse—a horse-drawn carriage—and my family in cars behind it began a processional, passing places in Harlem that were special to Sylvia. We drove by my grandmother's first home in Harlem, on 131st Street. We went past the Apollo Theater and the marquee said, "In Memory of Sylvia Woods 1926–2012." Under the marquee, a horn band was playing.

What we hadn't anticipated was how many people would be watching from their fire escapes and balconies. People began following behind us on foot. It wasn't planned, but it became a parade.

When we got to 125th Street, my family, dressed all in white, got out of the limousines and started walking with the people. We had sent invitations to restaurateurs asking them to meet us at the State Building and join the procession in their chef whites. I'd expected that they would be the only people walking with us, but by the time we got to 125th Street and Adam Clayton Powell Jr. Boulevard, hundreds of people were walking. And it was hot, in the middle of the summer. When we turned on Lenox Avenue heading to her restaurant, people were chanting, "Long live the queen, long live the queen." It was completely unplanned.

The day really took on a life of its own. It was unreal. I could hear my grandmother that whole time saying, "For me? Oh my God, thank you, Lord," holding her chest, with tears of absolute humility.

—AS TOLD TO EMILY SPIVACK

Tren'ness Woods-Black is the vice president of communications at her grandmother's restaurant, Sylvia's, a Harlem soul food institution, and the president and chief strategist of Tren'ness Woods-Black LLC. She is a native New Yorker.

WILLIAM
HELMREICH

I've already walked more than eight thousand miles throughout New York City. I average thirty miles a week of walking. When I finish this conversation, I'll walk some more miles. I walk in the morning, in the afternoon, and in the evening seven days a week, because neighborhoods change from morning to night and a street doesn't look the same on Sunday as it does on Wednesday.

I started out wearing SAS shoes. They looked like I was getting ready for a nursing home, but they were quite comfortable. I went through nine pairs. I walked five hundred miles in each pair before I had to replace them. I had heard, though, that Rockport shoes were even better and cheaper. I got a pair of their desert boots and walked most of Brooklyn using *two pairs*. That's eight hundred miles for around two hundred dollars and they still haven't worn out.

One of my feet is a half size larger than the other one, but what am I going to do? Get an 11 and an 11.5? You know what you do? You manage. I've been through far greater hardships walking every block of New York City—ice storms, ninety-five-degree heat, howling winds.

Once people heard that I had walked every block of New York City, they began asking me to do unusual things. A location scout wanted to find hidden-away parks for fashion shoots. I took her to Staten Island and showed her the boardwalk and the Chinese Scholar's Garden. Real estate developers hire me—not to figure out what neighborhood is gentrifying but what *block* in the neighborhood they should build on, because it's going to gentrify more quickly. Someone sent me a photo of the three-story house the author Philip Roth grew up in in Newark and asked if I could find a similar house in New York City.

When I go walking I always have a few things with me. I have my Omron pedometer. I purposefully chose one that fits on my belt. I have my iPhone, because I use it to interview

people. If I'm speaking on my cell phone and I see tough guys up ahead, I don't get off, because I don't want to show fear. When they see I am coming upon them and still talking on the phone, they know I'm not concerned about what they're going to do. Sometimes I'll carry pepper spray with me, but most of the time I won't. I rely on street smarts. I grew up here, and no pepper spray is going to stop a speeding bullet, I assure you. What are you going to say? "Excuse me while I open up this canister?" I always have a pen and paper. I wear dull colors and my Rockports. I carry a map of every neighborhood. In the evening, I use a yellow marker to delineate every block that I've walked. On occasion, I'll have to double back and walk a block more than once. This is both a science and an art.

I'm seventy years old, and age works in my favor. Once you hit sixty, you're invisible. I can walk into all sorts of places and no one pays the slightest attention to me. And for my work, that's a great thing. I don't want to be noticed. I just want to keep walking. And I want to stop and interview people along the way. I ask them how they feel about New York. "How's the weather?" "What's the neighborhood like?" "What's that horse doing in your backyard?"

I can't tell you how many times I've called my wife and said, "You know, Helaine, I have to tell you that this is when I'm happiest in my life—when I'm walking the streets of New York." To me, New York is this great outdoor museum.

In the late nineteenth and early twentieth centuries, walking was a great national pastime. People would walk from one end of the country to the other and crowds lined the streets, giving them food, providing them with encouragement. There's a book called *The Last Great Walk*, which was suggested to me by a Park Slope realtor. When I read it, I realized that I was reviving something from centuries ago. In Europe, there's a name for people who stroll the streets—a flâneur. I am a modern-day flâneur, even though I didn't realize it.

In walking terms, you can tell the tourists from the native New Yorkers. Tourists zigzag around, stopping, turning, and looking, whereas New Yorkers tend to walk with great purpose. They're going somewhere. When I'm walking on a crowded street like Thirty-Fourth Street, I'll fall in line behind a New Yorker and I'll just follow him because he clears the way for me. He doesn't know he's doing that, but I'm right behind him. Maybe I'm clearing a path for someone else, but I never turn around. I'm a New Yorker. Why would I do that?

—AS TOLD TO EMILY SPIVACK

William Helmreich is the author of *The New York Nobody Knows: Walking 6,000 Miles in the City* and Distinguished Professor of Sociology at the City College of New York and CUNY Graduate Center. He is a native New Yorker.

WILSON
TANG

I would take the E train to work, from Queens to the last stop in Manhattan. I worked for Morgan Stanley at Two World Trade Center on the seventy-fourth floor. I always arrived early. I'd get off the train, walk into the building, and take the express elevator to the forty-fourth floor, which is where the corporate cafeteria was. I would order two eggs sunny-side up, a side of bacon, and home fries, and then I'd take the local elevator up to seventy-four. I'd get to my desk, turn on my computer, let it boot up, and start eating breakfast.

On September 11, 2001, I was into my breakfast when I saw a lot of ticker tape or paper floating outside my boss's window. It was strange. Why was so much paper flying around outside, and especially so high up? It made me think about the Yankees winning the World Series.

Then the fire alarm rang. We were told to vacate. I was twenty-two years old at the time and any opportunity to not be working while I was on the clock was favorable. I took the local elevator from seventy-four to forty-four. At forty-four, when we'd typically transfer to an express, we were told to take the stairs.

When I reached the sixteenth floor, I saw people walking back upstairs. I saw firefighters going upstairs, too. I figured it might be a little fire and that I could probably turn around as well. But I knew that if I tried to get on the elevators at sixteen, they'd be packed. It would take forever because everyone would be trying to get back to their offices. So I continued walking down to the first floor. I'd planned to hang out a bit, scope it out, and then go back in and take the express elevator up.

I got outside and there was a lot of commotion. Everyone was looking up at One World Trade Center, like, "Whoa, crazy. There's a hole in the building." I thought maybe a Cessna or one of those small propeller planes must have gotten lost and flown into the building.

I remember saying, "This doesn't feel right." People were scrambling. It was chaotic. Police and firefighters were saying, "Vacate, vacate, vacate!"

I had my cell phone but it wasn't working, so I instinctually walked toward China-town, which is my hub. I grew up in Chinatown, my family is from Chinatown, my dad worked there, my uncle worked there. It was a Pavlovian response. If something happens, you go home to check in. I wanted to let them know I was safe.

By the time I got to my dad's restaurant supply business on Allen Street, the second plane had hit the building that I had been in. My dad was like, "Go home. Don't stick around here."

I kept walking. The only way to get back to my house in Elmhurst was to go over the Fifty-Ninth Street Bridge. As I walked up Allen to First Avenue, I picked up more news. I would listen to the radio from a car that had pulled over. A bunch of people at a bodega or bar would be huddled next to a TV with CNN on. I would poke my head in, check it out, and keep walking. I heard that the first tower fell and then the second.

I was walking by myself, but I would pick up conversations with people along the way. We would bond for a couple of blocks and relive what had happened to each of us. I'd con-tinue on and pick up another conversation. People needed to talk to each other to keep sane.

From the time the fire alarm went off to the time I got home three hours later, my mood went from "Cool, I can skip out of work for a little bit," to "I'm probably off all day," to "Wait, my building isn't there anymore," to "Oh shit. This is really bad."

The fact that I was so young and naive saved my life. I was still in a childish stage where I was thinking about milking the clock before going back to work. If I had been a guy that had deadlines or higher-level work, I would have gone back upstairs.

I remember everything I was wearing that day—the shoes, the pants, and especially the shirt. The last time I wore it, I ripped the sleeve. Because it's one of my favorite shirts, I have taken it to a tailor and had the sleeves repaired three times. I haven't worn it in years because the thing is basically disintegrating. It's so fragile, but despite its condition, I'll never throw it away. It stays in my closet. I'll take it out once in a while just to look at it and think about that day.

That event made me change gears. I went into my family's business, and for the last six years, I've been working in Chinatown. After I got married, we moved to the finan-cial district, four blocks from the new World Trade Center. I'm living basically where I almost died sixteen years ago. I always take a moment of silence while I walk through the memorial that's right by my house, now with my wife and kids. I say to myself, "I'm here, I'm alive, and I'm doing well."

—*AS TOLD TO EMILY SPIVACK*

Wilson Tang is the second-generation operator of Nom Wah Tea Parlor, which has been open since 1920. He is a native New Yorker.

ACKNOWLEDGMENTS

Making a book, especially one with sixty-eight contributors, is not a solitary effort, and I am grateful to many people who helped along the way. First, *Worn in New York* would not be possible without the openness of those contributors who shared their stories with me. Thank you for talking with me about the lives you've lived in the clothes you've worn.

This book stayed on track with assistance from Thea Macdonald and Netta Rosin. Thea's attention to detail, insight, and dedication to the project and Netta's keen sensibility, thoughtfulness, and organizational know-how were indispensible.

For their invaluable counsel and feedback and their willingness to hop on the phone or get together to talk through ideas, my deep appreciation to Amanda Katz, Catherine Pierce, Maria Popova, Shana Lutker, and Stacey Reiss.

For their suggestions, brainstorms, and introductions from the time I began dreaming up this book, many thanks to Alessandro Esculapio, Anna Burkhardt, Ariana Green, Betty Buckley, Blair Whiteford, Carole Aaron, Chris Barley, Giselle La Pompe-Moore, Isca Greenfield-Sanders, Jelani Day, Jenna Wortham, Joshuah Bearman, Liz Magic Laser, Mamie Minch, Marc Kushner, Matt Wolf, Molly Schiot, Natalie Finch, Rachel Brennecke, Rachel Schwartz, Ross Intelisano, Tal Schori, Ted Passon, and Timothy Greenfield-Sanders.

For his guidance throughout the book-making process, thank you to my agent, Jud Laghi. For her enthusiasm about my work and this book specifically, thank you to my editor, Rebecca Kaplan. Thank you, also, to Emma Jacobs, Gabby Fisher, John Gall, Meredith Clark, Najeebah Al-Ghadban, and Paul Colarusso at Abrams for helping to bring *Worn in New York* into the world. For doing all I had hoped with the book's images, thank you to my photographer Bon Jane.

For their unwavering love and support, even when they're not entirely sure what it is I'm doing, my immense gratitude to my family—Marcy Spivack, Dennis Spivack, and Lauren Spivack.

For everything, Ian Chillag, thank you. You have changed everything.

To the people who called in to share their sartorial memoirs on air when I was a guest on a New York City public radio show in 2014 and who blew me away with their candid recollections, thank you. This book is because of you.

And even though you don't always make it easy, thank you, New York City, for being my home.

Editor: Rebecca Kaplan with Emma Jacobs
Designer: John Gall
Co-Designer: Najeebah Al-Ghadban
Production Manager: Alex Cameron

Library of Congress Control Number: 2017930312

ISBN: 978-1-4197-2707-8

Published in 2017 by Abrams Image, an imprint of ABRAMS. All rights reserved.
No portion of this book may be reproduced, stored in a retrieval system, or
transmitted in any form or by any means, mechanical, electronic, photocopying,
recording, or otherwise, without written permission from the publisher.

Printed and bound in the United States
10 9 8 7 6 5 4 3 2 1

Abrams Image books are available at special discounts when purchased
in quantity for premiums and promotions as well as fundraising or
educational use. Special editions can also be created to specification. For
details, contact specialsales@abramsbooks.com or the address below.

ABRAMS
The Art of Books

115 West 18th Street
New York, NY 10011
abramsbooks.com